Watercolor
Composition
made easy

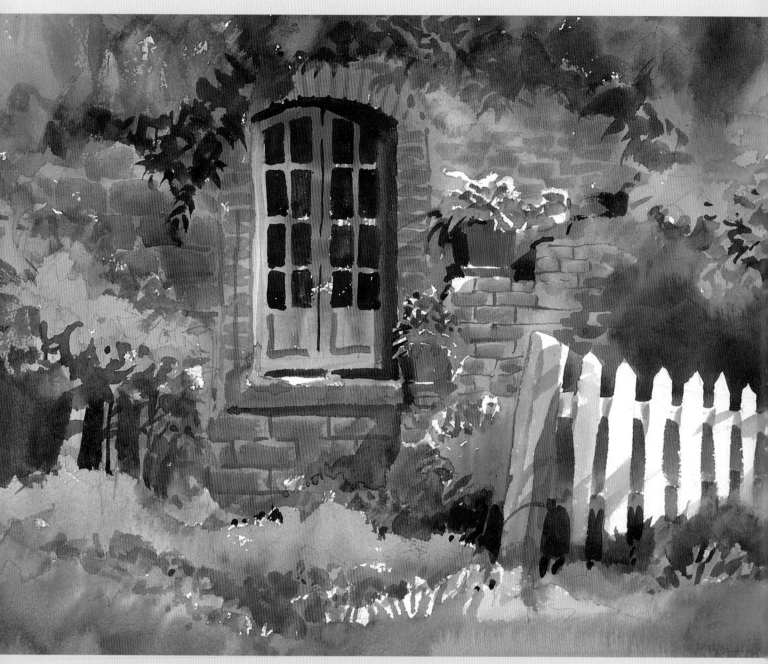

Window Treatment
David R. Becker
Watercolor on Arches 300 lb. rough paper
14″×22″ (36cm×56cm)

Watercolor
Composition
made easy

David R. Becker

NORTH LIGHT BOOKS
CINCINNATI, OHIO

about the author

David R. Becker, MWS (Midwest Watercolor Society), is a respected illustrator, watercolor artist and art teacher.

His paintings have been published in several books and magazines including *People in Watercolor, How to Make a Painting* by Irving Shapiro, *Splash 3: Ideas & Inspirations* and *American Artist* magazine.

Becker's work has been accepted into more than two dozen shows and he has won many prestigious awards including The Honorable Order of Kentucky Colonels in the Bluegrass Painting Exhibition; Bronze Medal at the Solon International de la Peinture de Sherbrooke, Canada; and Purchase Awards from The Degas Pastel Society, Niagara Frontier Watercolor Society and The Montana Watercolor Society.

He is a signature member of the Midwest Watercolor Society and has reached signature status in the Ottawa Watercolor Society and the Mississippi Watercolor Society.

Becker began teaching watercolor part-time while still a student at the American Academy of Art in Chicago. In addition, he has taught classes at the Palette and Chisel in Chicago and the Studio of Long Grove in Long Grove, Illinois. He has also led many workshops.

Becker was chairman of the Palette and Chisel 100th Anniversary and the 2nd Annual National Irving Shapiro Watercolor Competition and Academy Reunion in memory of Irving Shapiro. He studied painting with Shapiro while a student at the American Academy of Art where he graduated with a Fine Arts degree in 1983.

A native of Chicago, Becker has been an illustrator at Impact, the promotion division of Foote, Cone & Belding, for the past eight years. Previously, he was an illustrator at J. Walter Thompson. He has received numerous corporate commissions to create paintings for companies including Levy Restaurants, Wendy's Restaurants, Citibank, Illinois Department of Tourism, AT&T, Ace Hardware, Motorola, Kraft Food, Kemper Financial and Nestle USA.

Becker has appeared on WCIU-TV in Chicago and on "American Art Forum" with Richard Love to discuss art and painting.

He resides in the Chicago suburb of Ingleside, Illinois, with his wife and three children.

Watercolor Composition Made Easy. Copyright © 1999 by David R. Becker. Manufactured in China. All rights reserved. No part of this book may be reproduced in any form or by any electronic or mechanical means including information storage and retrieval systems without permission in writing from the publisher, except by a reviewer, who may quote brief passages in a review. Published by North Light Books, an imprint of F&W Publications, Inc., 1507 Dana Avenue, Cincinnati, Ohio 45207. (800) 289-0963. First edition.

Other fine North Light Books are available from your local bookstore, art supply store or direct from the publisher.
03 02 01 00 99 5 4 3 2 1

Library of Congress Cataloging-in-Publication Data

Becker, David R.
 Watercolor composition made easy / David R. Becker.
 p. cm.
 Includes index.
 ISBN 0-89134-891-3 (hardcover : alk. paper)
 1. Watercolor painting—Technique. 2. Composition (Art) I. Title.
ND2422.B33 1999
751.42'2—dc21 98-56085
 CIP

Editor: Joyce Dolan
Production editors: Christine Doyle and Marilyn Daiker
Production coordinator: John Peavler
Designer: Mary Barnes Clark

Other paintings by David R. Becker can be seen in the following works:
People in Watercolor. Selected by Betty Lou Schlemm. Rockport, Massachusetts: Rockport Publishers, 1996. Distributed by North Light Books, Cincinnati, Ohio.
How to Make a Painting, by Irving Shapiro. New York: Watson-Guptill, 1985.
Splash 3: Ideas & Inspirations. Edited by Rachel Rubin Wolf. Cincinnati, Ohio: North Light Books, 1994.

dedication

This book is dedicated to my mom, Hannelore, and my
dad, Volkhard; to Sharon, my wife, and Tara, Devin
and Dennis, my wonderful children.

Dedications also go to all my wonderful relatives.
Without my family I could never have gotten as far as I have—
their influence, understanding and love is
what makes life so grand.

appreciation

To my students who make me feel like a big shot—
we'll be friends forever.

To my teachers at the American Academy of Art, who taught me
how wonderful art can be: Robert Krajecki, Arvydas Algminas,
Ted Smuskiewicz, Bill L. Parks and Irving Shapiro.

Special thanks to Irving Shapiro for helping
me in so many different ways.

To Max Ranft and Sally Augustiny, two of the best artists
I've had the pleasure of working side by side with
for six years. Thanks for your friendship and all the
knowledge I got from just watching you.

To Robert Wade for giving me advice and critiques
when I first started learning about watercolor
and for corresponding with me ever since.

To Rachel Wolf, Joyce Dolan and everybody else
at North Light (especially Mary Barnes Clark, Christine Doyle
and Marilyn Daiker) for making my dream come true
and helping every step of the way.

table of contents

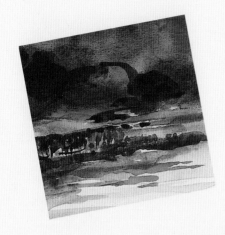

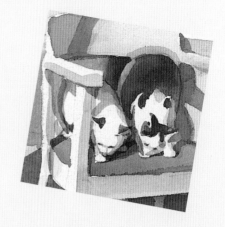

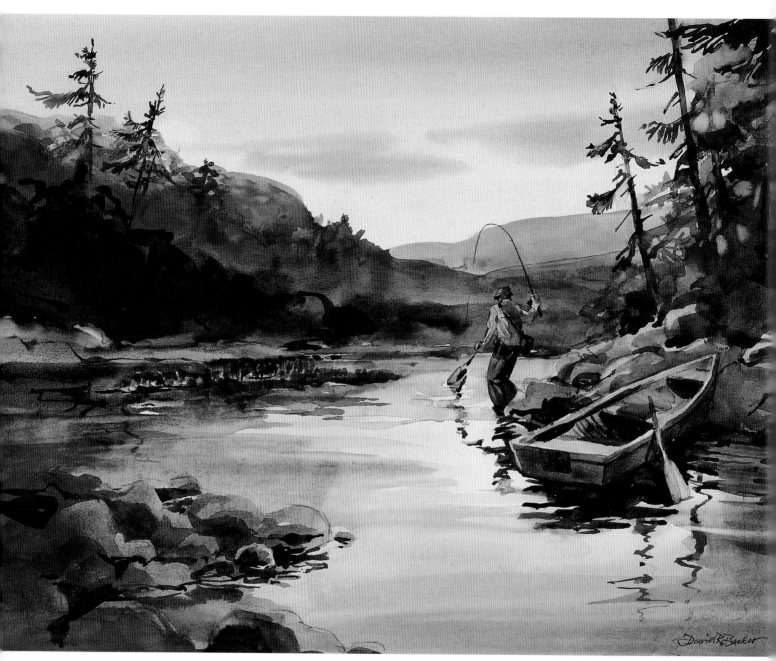

Colorado Fisherman
Strathmore Crescent 114
Cold-press board
13″×19″ (33cm×48cm)

Introduction

I've been very fortunate to have many of the finest instructors teach me that learning the fundamentals is the most important element in creating and composing fine art. A firm grasp of the basics is essential to creating a wonderful work of art.

In this book I'll emphasize how important the fundamental principles are in helping you compose skillfully executed works of art. I'll repeat them often in a variety of ways. When reading this book and doing the exercises, follow my ideas and do what I say—then later you can work the way you did before but add what you feel helped you out and eliminate what didn't feel right for you. The process will help you grow.

Most of all, use the book and practice. Practice is the best advice I can give anyone who wants to create good artwork.

Have fun and enjoy the learning process because good paintings will come from it. Enjoy and happy painting.

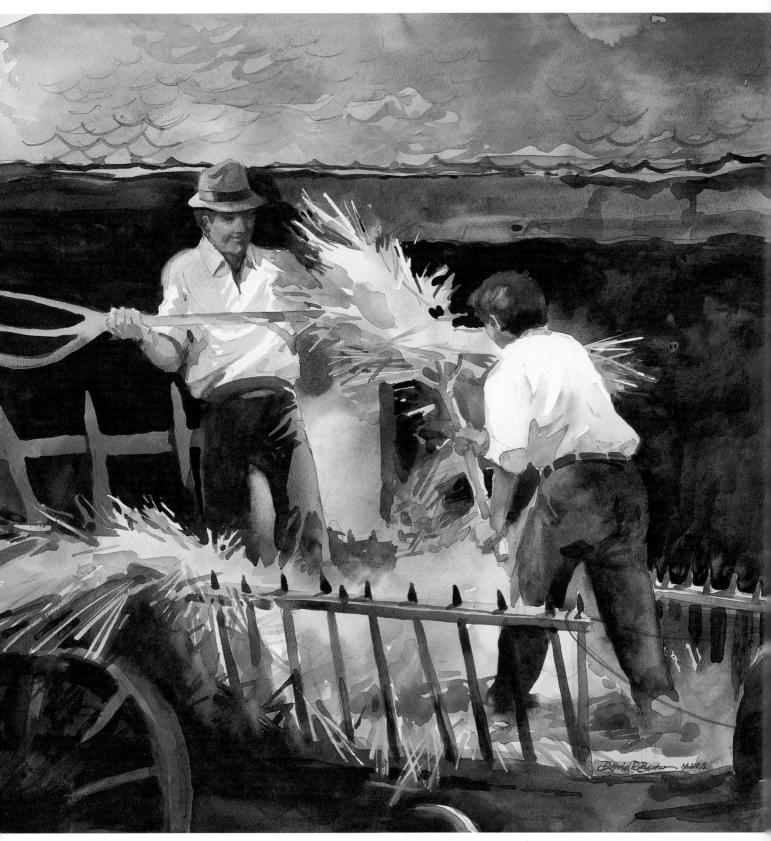

Hay Balers
Strathmore 5-ply bristol board
19″×23″ (48cm×58cm)

1 Composition—An Overview

Let's get right to the point and make it simple and basic. In artistic layperson's terms, composition means creating a painting in which objects are patterned and placed in a way that is pleasing to the eye. There should be a visual flow to the painting. When non-artists look at art they don't necessarily understand composition—they just know they like or dislike the painting. This feeling is caused by the skilled or unskilled use of composition.

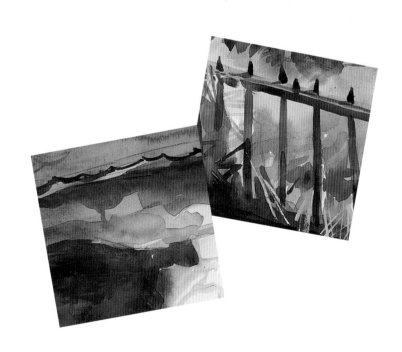

Composition Defined

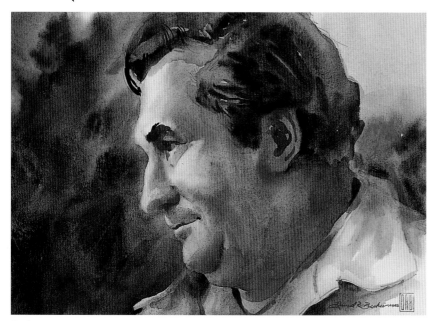

Dad
Arches 300-lb. (640gsm) rough paper
10″×14″ (25cm×36cm)

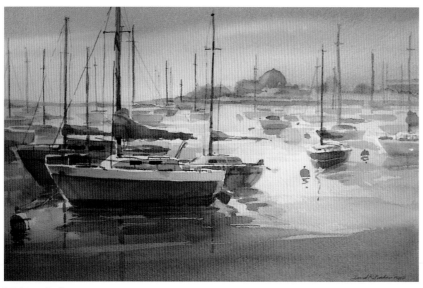

Michigan Sailboats
Arches 300-lb. (640gsm) rough paper
14″×21″ (36cm×53cm)
Collection of Carol A. Kelly

Shape

The shapes in a composition make up the large light and dark masses. The face, which is light in this painting, stands forward and the darks, behind the head, fall back. Your eyes see the face first, then take in the background, then return to the face. Even in a more complex painting, like a landscape with sky, mountains, trees and foreground, simplifying the large complex shapes makes the painting easy to compose.

Squint your eyes while looking at this painting. Squinting takes away the color and the midtones. You're left with large value masses. These large masses are what you use to create a simplified value sketch.

Line

We work with lines when drawing a value sketch, when laying out the drawing on watercolor paper and when the objects in a painting actually consist of lines, like a wire fence or the ropes on a sailboat. There are times when you can direct the compositional flow using the perspective of lines. For example, use a thin wire fence or branches to lead the viewer's eye around the painting. However, avoid using lines to show dimension or to show the edge of an object. Instead, change values at the point where the object either turns or overlaps another object.

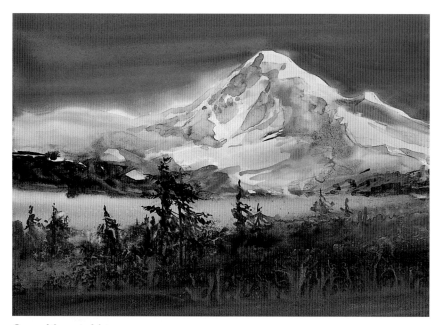

Orange Mountain Majesty
Arches 300-lb. (640gsm) rough paper
13″×19″ (33cm×48cm)

Value

Value in this context is the areas of light and dark that make up a composition. You can simplify complex areas with similar values. For example, if similar value is used for all objects in a complex foreground, a single value mass is created. If all the detail in this dark mass stays at approximately the same value, it holds together as a large pattern of dark. The simpler the value pattern, the better and easier the composition will be.

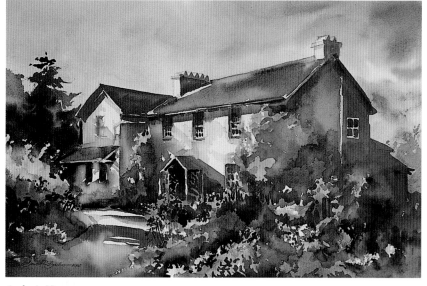

Author's House
Arches 300-lb. (640gsm) rough paper
14″×21″ (36cm×53cm)
Collection of Joan Miller

Color

An easy color rule to remember is to use intense colors in the foreground and in the center of interest; use less intense colors as you work away from the center of interest and get into the background. Keep it simple! Let the values, shapes, edges and lines take care of the composition pattern.

Color should be the last element on your list to use to create good composition, but it is beneficial and will add a lot to an already well-thought-out composition.

EXERCISE

Study a photo reference for about ten minutes. Now put the photo away and see if you can draw the large shapes that make up the light and dark pattern of the painting.

Center of Interest and Eye Flow

Party Time
Arches 300-lb. (640gsm) rough paper
14″×20″ (36cm×51cm)

Visual Tour

As an artist you must get a viewer to first see the center of interest or an area of interest in a painting. The center of interest isn't always a single object that stands out by itself but can be an area of interest that brings the viewer into the painting. From that point, the pattern of the composition takes the viewer on a tour through the painting but always returns to the center of interest. The composition must be evenly balanced and weighted so the viewer doesn't get thrown off the visual tour. The eye should flow as a subconscious reaction to the composition of the painting.

Flow

All good paintings have flow—still lifes, portraits, landscapes, montages, silhouettes, abstracts and vignettes. Still lifes and abstracts may not have as much depth as a landscape, yet you still need to show depth, balance and flow to make a good composition.

> ### TIP
>
> Use your signature as a compositional flow device. If your eyes want to run off the corner of the page, put your signature in that corner to stop them and bring you back into the painting.

Sharon's Vanity
Arches 300-lb. (640gsm) rough paper
17″×13″ (43cm×33cm)

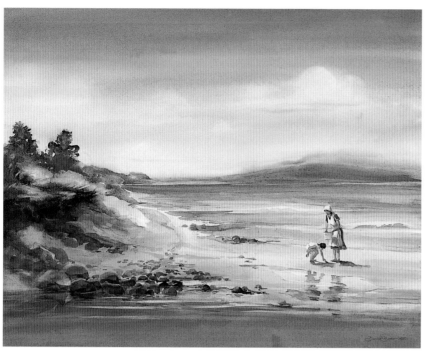

Shell Seekers
Strathmore 5-ply bristol board
21″×27″ (53cm×69cm)

Follow the Flow

Here's an exercise to try any time you see a painting you admire. As you view this painting, follow the compositional flow that your eyes take. First, find the center of interest. Then, let your eyes wander through the painting, keeping track of the directions you take by following along with your finger. In the end you should return to your center of interest.

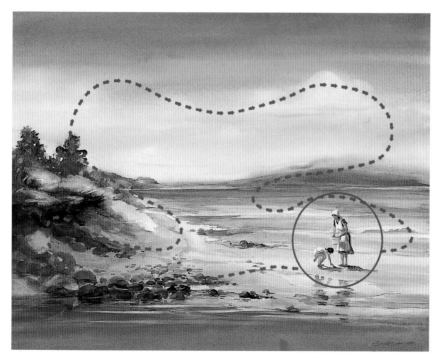

Flow Illustrated

I've illustrated here how I had intended the viewers' eyes to travel through this painting. There can be many routes to the flow of a painting, so although your visual flow may not be the same as mine, it may still be appropriate. When creating your own painting, just make sure you have good patterns, balance and depth in your composition, and always make sure you visually come back to your center of interest.

Arrangements to Avoid

Don't cut your canvas in half. Think of your painting as sitting on a pendulum scale. Try not to overweight one side.

Stay away from an even number of objects. Use an odd number instead. Variety is the spice of painting. Stay away from a formal layout, where objects mirror each other, when you're first learning. Challenge yourself to use informal layout—you'll learn more than if you use only formal layout, and you'll be a more effective painter.

Avoid too many parallel lines. An abundance of lines running in the same direction will ruin the flow of the composition.

Stay away from the edge. Objects that run along the edge or end up tangent to the sides may cause the eye to flow off the edge of the painting.

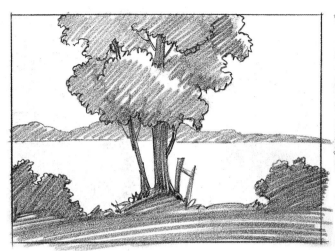

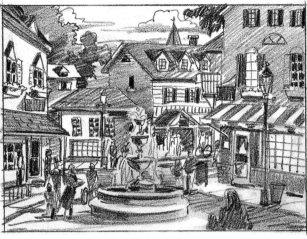

Don't place objects in the center. Objects of interest shouldn't be placed in the center of your picture. This is an example of formal composition which, although easier than informal composition, should be avoided by beginners. Place the objects off-center and challenge yourself to compose the painting using informal layout.

Avoid overcrowding. Simplify crowded compositions by joining complex objects together to create large value masses.

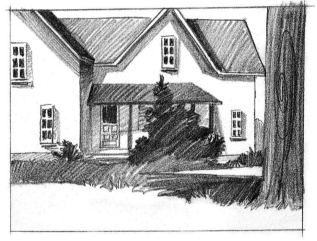

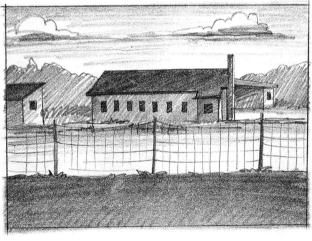

Keep tangents out of your painting. Overlap your objects instead of letting them touch each other at a point or at the edges.

Avoid equal spacing or divisions of objects or masses. Instead of dividing your composition in even thirds, divide it so none of the masses are equal.

TIP

Don't paint subject matter that doesn't make sense or is an oddity. For instance, don't paint a tree that has grown around an object making the tree look unnatural. It may look interesting in the photo, but it won't work as a painting.

Fix the Compositions

What Looks Better?

In these two photos there are a number of bad compositional elements. List the problems and then figure out how to make the composition better. Draw up a rough sketch of your own. Then take a look at how I remedied the problems. There are many ways you can change the compositions to make them work. Your changes might not be the same as mine but can still be correct.

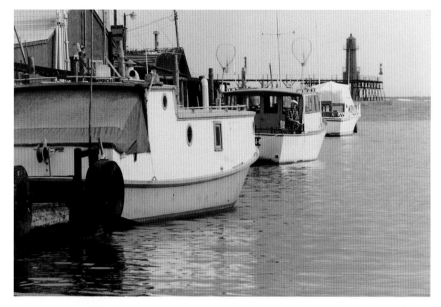

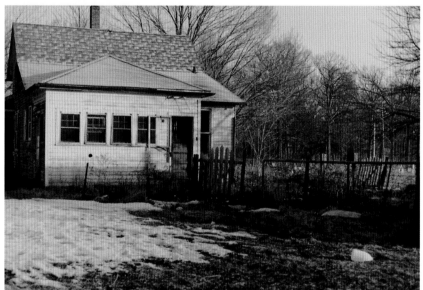

TIP

Sometimes objects can be drawn physically and perspectively correct and yet still look wrong in your scene. When this happens, use your artistic license and change them in any way that works, even if it breaks the rules.

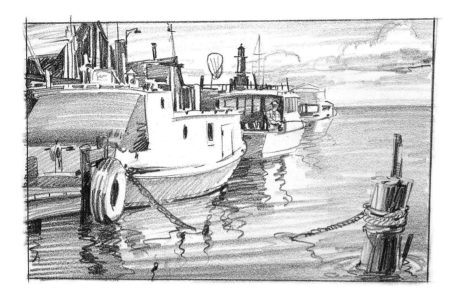

Problem: The photo of the boats doesn't work because the direction of all the boats takes your eye visually off the upper right corner of the picture. The water also takes on a geometric, triangular shape which divides the photo in half from opposite corners.

Solution: I widened the dimension of the picture and put in a post, some rope and clouds to get rid of the triangle. This corrects the composition and gives the painting balance and flow.

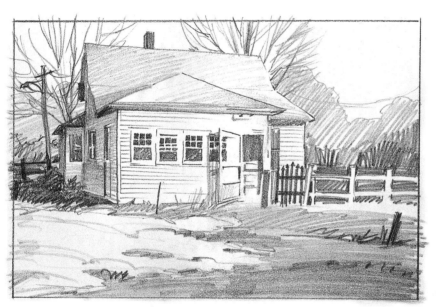

Problem: The house cuts the painting in half and weighs the composition to the left. Both the house and snow are of the same light value while the entire right side of the composition is dark.

Solution: I moved the house over to the one-third position of the painting. The house then clearly becomes the center of interest. The shadow side of the house, which I made up from my imagination, is dark enough to balance out the snow. The light-valued fence on the dark right side helps to balance this area of the painting. The sketch now has a compositional flow.

Value and Sideline Sketches

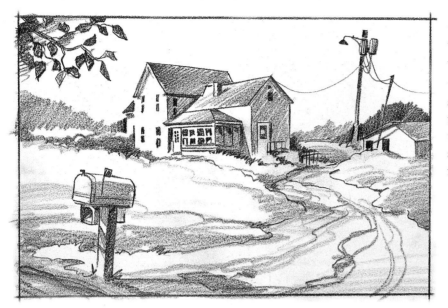

Blueprint

When composing and painting a picture, a value sketch is always necessary. (It's the blueprint you work from to create a painting.) Because they're so important, value sketches are discussed at length in chapter four.

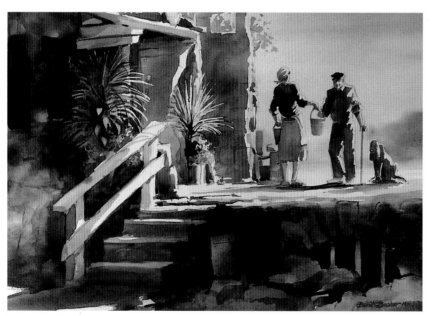

Thousand Island Day
Strathmore 112 rough board
14″ × 19″ (36cm × 48cm)

Sideline Sketch

Little studies done to work out a small problem are what I call "sideline sketches." They can be done on a scrap piece of paper or canvas. See the opposite page for how I used a sideline study to insert the people into this painting. Sideline sketches are helpful when working out figure drawings, shadows and negative painting and when grouping complex objects to create one value mass.

TIP

Use a soft lead pencil when drawing value sketches. It gives you a full range of values. Don't use pencils graded H for shading. They don't give a good range of values.

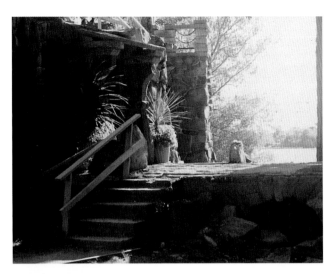

Recompose Reference Photo
This photo was taken in Thousand Island, New York. It turned out a little lopsided, so I needed to recompose the upper-right corner. I decided to add people to bring the painting back into balance.

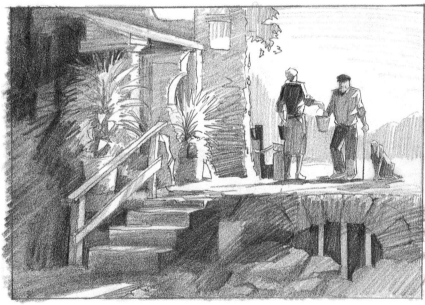

Rough Value Sketch
The next step is to create a rough value sketch. Don't include much detail at this point.

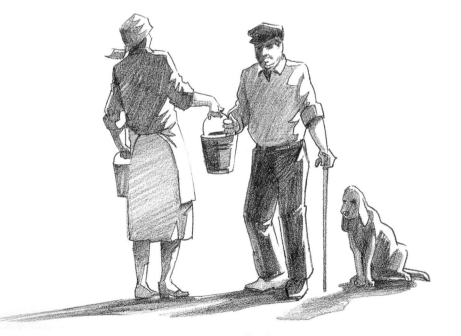

Sideline Sketch
After the value sketch, do a sideline sketch of the figures or anything else you feel needs more attention. Sideline sketches help you with the drawing, lighting and negative painting of the objects. Follow the sideline sketches to put the pencil lines to your watercolor paper. While painting, keep in mind the procedure you went through to create the value sketch and sideline sketches.

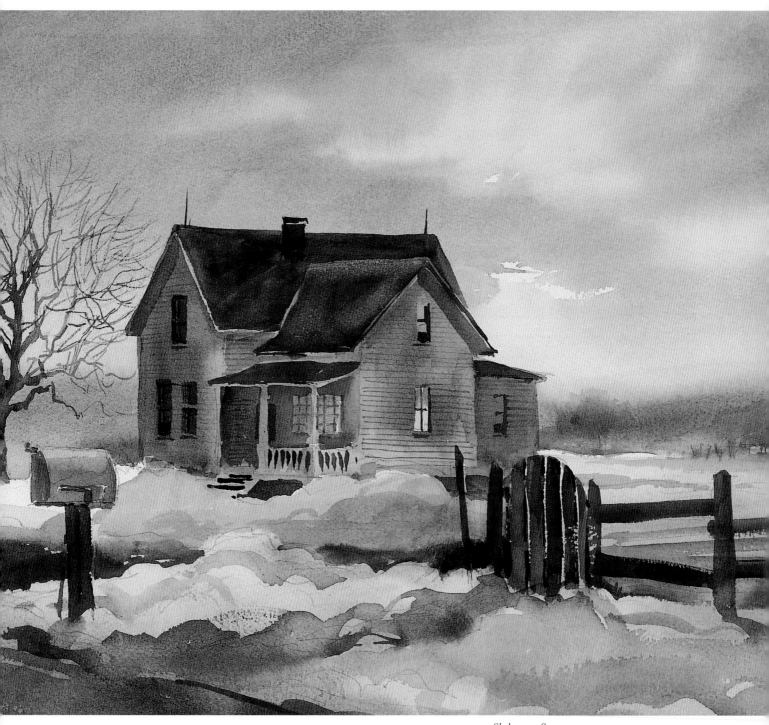

Sheboygan Sunset
Arches 300-lb. (640gsm) rough paper
15″ × 21″ (38cm × 53cm)

Tools for Good Composition

Is it just me, or does every artist love going to art supply stores and fantasizing about that dream studio stocked with every supply and gadget available? We feel with all those supplies and gadgets we'd become great artists. Thank goodness it doesn't cost anything to dream. The nice thing about watercolor painting is that you really don't need loads of art supplies to get started. Watercolor paper, brushes, a palette, paint and a few miscellaneous supplies and you can become a watercolorist. A camera, copier, computer, etc. are also useful in composing your paintings. In this chapter I'll discuss how to use these materials and equipment to your advantage.

Basic Materials

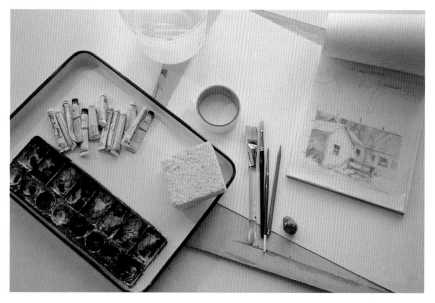

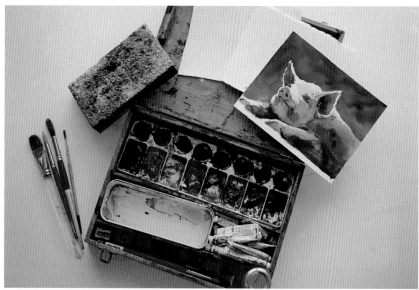

All You Need

Creating watercolors is a low-cost investment that can bring you many years of enjoyment. Shown here are all the basic supplies you really need to do a watercolor from beginning to end.

You need at least three brushes: one big flat, one big round and one small round. The brushes I use most often are: a 1-inch white nylon sable, a no. 10, 12 or 14 round white nylon sabeline or sablette, and a no. 2 or no. 4 lettering white round nylon for detailing.

Paint and paper should be of good quality. Don't buy student-grade paint or lower-grade paper just to save a few bucks. Professional grades are a better choice. I prefer Arches 300-lb. (640gsm) rough and cold-press paper and Strathmore Crescent watercolor board rough and cold-press. I use Winsor & Newton Utrecht paints.

Other materials you'll need are: pencils, eraser, sketchbook, paint tray, tape, a board to mount the paper onto, a sponge, a water container, liquid frisket, and if you're into techniques, some salt and a spray bottle.

The small wooden box is my watercolor setup for painting on the spot—for instance, on the train commute home or even at an airport or restaurant. The box has the same basic materials as my studio setup, just compacted enough so I can paint anywhere.

EXERCISE

More important than the materials themselves is the time you spend using them. Draw. Draw. Draw! Your skill is what counts when it comes to composing a picture. I'm not against using any gadget or supply, but not as a substitute to learning the basics like drawing.

My Studio

I've spent my share of time painting at a kitchen table or in a cold, dark basement, always dreaming of a well-lit, north-light, high-ceilinged studio. When I first saw the house I currently live in, I noticed an old shack in the backyard. I was instantly sold, knowing that some day I'd turn that shack into my dream studio. Five years and a sore back later, I now have somewhere I can get some serious painting done.

TIP

For good, inexpensive lighting, use a regular warm lightbulb and a cool fluorescent light. When these are combined the effect comes very close to natural light without the high cost of special lightbulbs and fixtures.

Use Your Camera to Compose

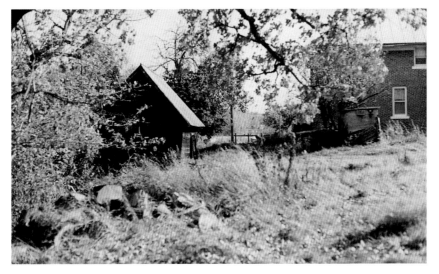

Telephoto Lens

The camera can be a useful tool when composing a picture. If you own a telephoto lens that adjusts from close-ups to wide angles, you can compose by standing nearly in one spot and letting the camera do the work. The following photos were all shot at one location. Find a likely spot and try using a telephoto lens in this way. Take a shot, walk a few steps and take another. Try to compose a good photo each time. Think of it as if you're framing a picture.

Set Up Your Shot

Search for a center of interest, and then zoom back and forth looking for a good composition. If you can't find a decent composition, don't shoot until you can at least get a shot that can be changed. Take your time—don't just point and shoot. You'll be surprised how much better your photos turn out and how much film you save. In the long run it also saves a lot of time that is better spent in the actual painting process.

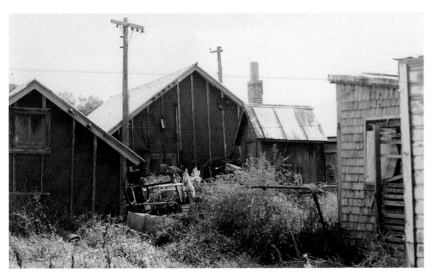

Reference Only

Keep in mind that the photos are just reference material. You will turn them into well-composed paintings that bring emotion and delight to viewers. Never copy the photo exactly. A photograph can't capture what you experienced as you shot it. Its purpose is to remind you of what you saw. In addition to taking the photo, also sketch the scene and take notes.

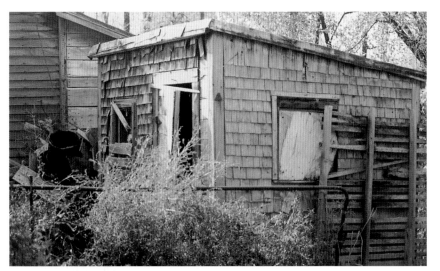

Center of Interest

After finding a spot you feel has interest in general, pick a specific center of interest or area of interest. Ask yourself what it is about this spot that makes the center of interest a worthwhile picture. Is it an object or is it the overall lighting effect that makes it look good? Try shooting a vertical and horizontal of your center of interest.

Simplify Masses

To create something more special than a photo, you need to simplify large masses of light and dark. Try not to copy the color exactly as it is in the photo. Again, throw away any notion that everything needs to be exactly like the photo.

Work At It

When you record data with your camera, digital camera or even video recorder, keep your painting objective in mind. Don't just snap away in hopes that one photo will turn out great.

Copy and Crop

Use a Mat

Many times there are sections of a photo that, if cropped, would make up a good composition. Take an old mat and cut it apart to create two L-shaped pieces. Use these two mats as a framing device for photos as well as paintings that need to be cropped. You can also use these mats after your painting is finished to see what size opening you'll need to cut for your final mat.

Three Pictures From One

Here's a way to get extra mileage out of your photos. Use two L-shaped mats to crop out different compositions from a single photo. If the original photos are too small to crop, enlarge them with a photocopier. After finding the right composition from the cropped photo, make sure you still do a value sketch. The value sketch not only helps you with the composition but with every other aspect of creating that painting. (See chapter four for a detailed discussion of value sketches.)

TIP

Always tackle any subject you're interested in, whether you think it hard or easy. Just make sure you're inspired by the subject matter, and then experiment, trying different types of references, styles and techniques.

Crop a Finished Painting

Rescue

Even with all the planning in the world, sometimes paintings just don't meet your expectations. If a painting seems like it can be rescued by cropping, then by all means do so. The top part of this painting just didn't work out like I had planned, so I decided to crop it to make a long horizontal painting. This resulted in a good design with a better composition.

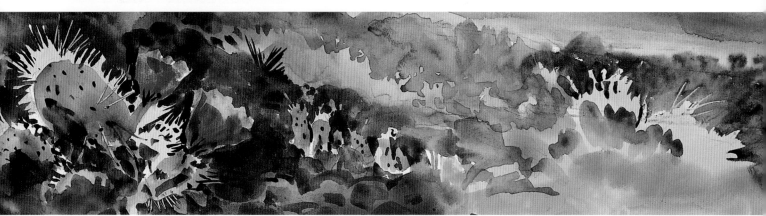

Cactus
Bristol board
13" × 22" (33cm × 56cm) originally, then cropped to 7" × 22" (18cm × 56cm)

TIP

Before buying costly equipment, try to borrow or rent it. This gives you the opportunity to work on the equipment and decide if it helps you and if you really need it.

From Photo to Painting

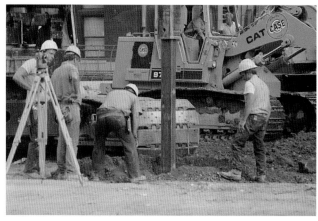

Reference photo

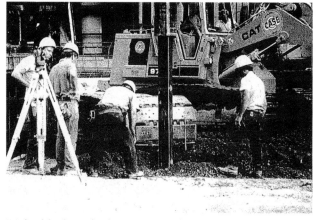

Make black-and-white copies of your color reference photos. This copy showed me the large masses were too close and too busy. Remove the color from a photo and check the value pattern before you start composing your value sketch.

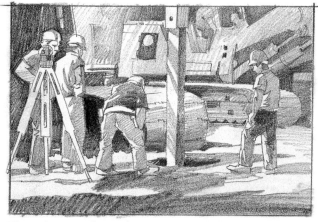

The reference photo shows overcast light, but I felt more light and shadow was needed, so I added sunlight to the value study. This makes a more interesting and simpler value arrangement.

Looks A-Okay
Strathmore Crescent 114 cold-press board
13″×19″ (33cm×48cm)

The Computer

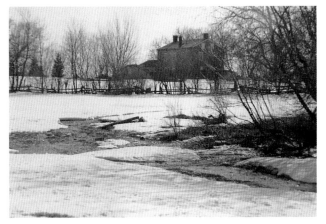

New Technology

Don't be close-minded to all the technology available today. Sure, nineteenth-century artists like Winslow Homer, John Singer Sargent and Anders Zorn didn't have the technology we have—but that doesn't mean they wouldn't have used it if they had. I combined these two photos to make one composition. To help me picture what it would look like, I used the computer to actually make it happen. I scanned both photos into my computer, and with a photo-manipulation program I combined them digitally. You can see the result here.

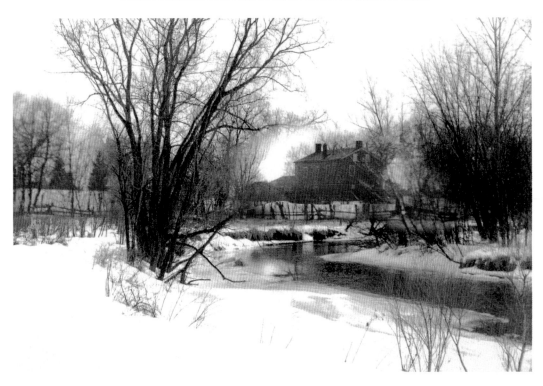

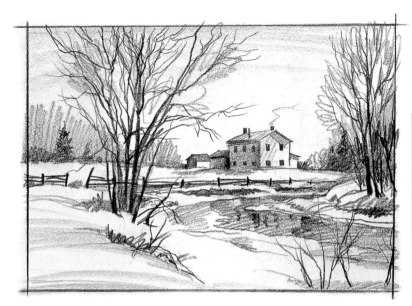

You don't need to go out and buy a computer to combine photos to paint, however. By doing a value sketch you are in effect doing the same thing.

TIP

Remember, the computer is just another tool. You, as the artist, need to come up with the idea and design for your painting. Technology can't replace hard work and experience. You need to be able to draw and paint the works of art and this means practice, practice, practice.

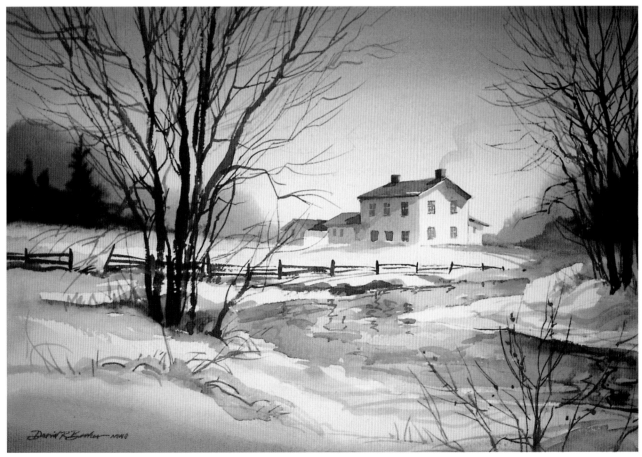

Spring Grove River
Arches 300-lb. (640gsm) rough paper
11″ × 17″ (28cm × 43cm)

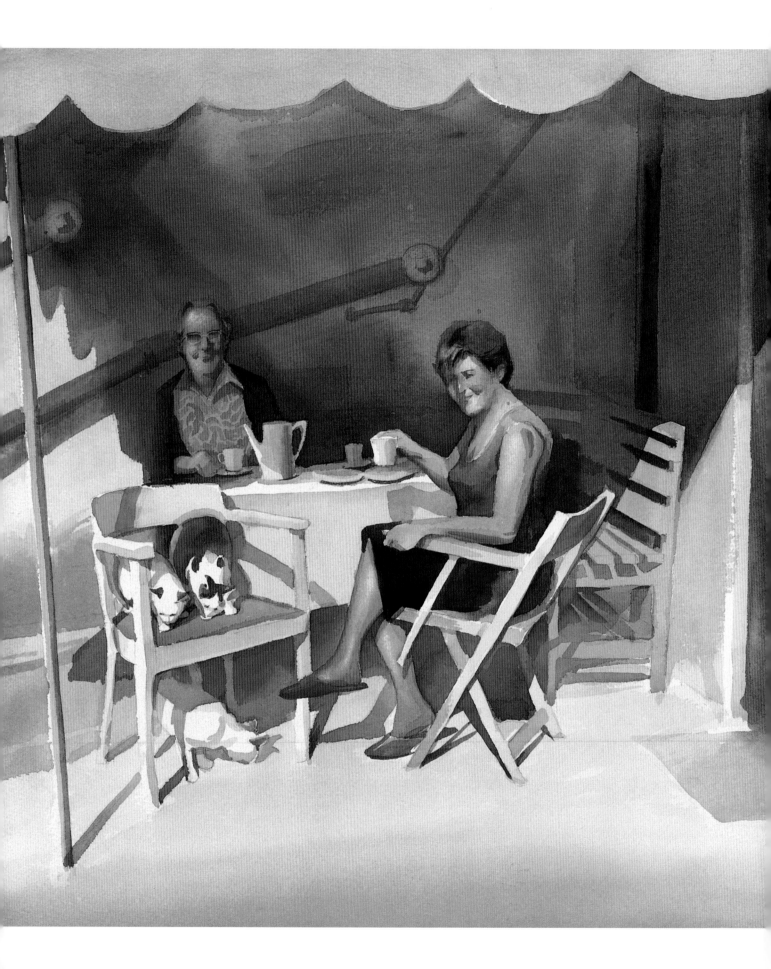

3 Your Subject Matters

You don't need to travel to faraway places to acquire good reference material and become a good artist. Paint subjects you have knowledge of, you have access to and that have some personal meaning to you. Look for subject matter that inspires you to paint.

Tea Time With Cats
Arches 300-lb. (640gsm)
cold-press paper
19″ × 22″ (48cm × 56cm)

Paint What You Know and Love

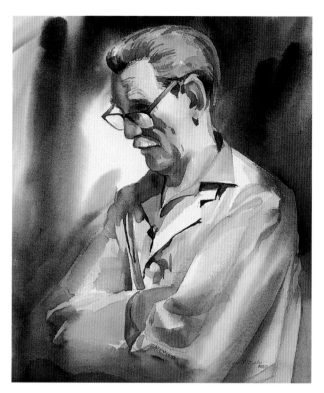

Make Your Subject Matter

It's important to have knowledge of the subject you're painting. It gives the painting reality. Visually artists will put more effort into a painting that means something to them. Good subject matter is everywhere, but good instructors like the one in this painting are hard to find. Mr. Parks is one of those instructors whose words and instruction will live on in me forever.

Mr. Parks
Arches 300-lb. (640gsm) rough paper
19″ × 16″ (48cm × 41cm)

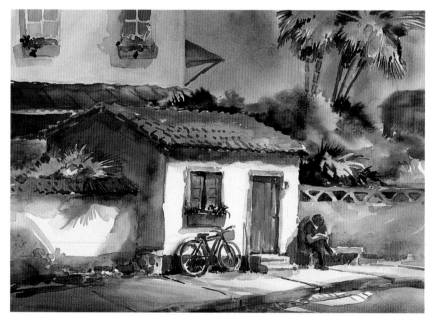

Know Your Subject

Paint subjects that you have knowledge about but also are interested in. It makes the tough process of learning to paint more pleasant. If you don't have knowledge of your subject and the subject isn't appealing to you, the painting will be a train wreck waiting to happen.

Island Dreamland
Strathmore Crescent 112 rough board
14″ × 19″ (36cm × 48cm)

EXERCISE

Invent your own techniques, like using a credit card for scratching lines into a wash. I was told John Pike, an admired artist, dropped cigarette ashes into a wash to create an interesting effect. Painting shouldn't always be hard work—have fun and don't always worry how the painting will turn out.

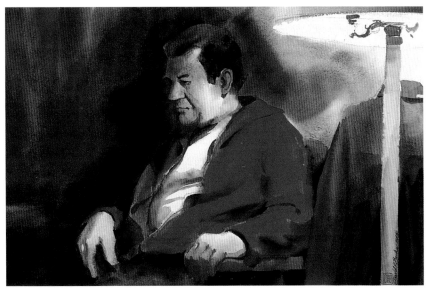

Dad Watching
Arches 300-lb. (640gsm) rough paper
12″×20″ (30cm×51cm)

Friends and Relatives

As you begin a painting, don't get caught up in trying to capture a likeness and character in a person and particularly not in a relative. This makes the painting way too tight, and you'll forget to look for the big picture. Don't think detail until you get the large areas and patterns worked out. If relatives want to sit for you, make sure you tell them the work is only a study and not a finished painting. This takes off the pressure to come up with a masterpiece that they'll accept. The key is, if you get the chance to work from life, take it, but do it as a study to learn from.

Let Style Happen

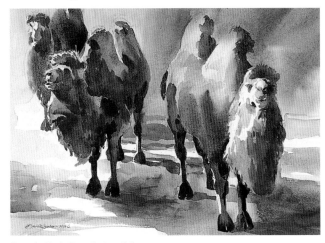

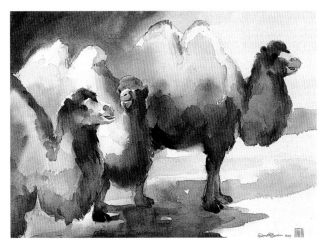

Lincoln Park Camels 4 and 5
Arches 300-lb. (640gsm) cold-press paper
Both are 13″×18″ (33cm×46cm)

Don't get caught up in worrying about your style. Style is something that just evolves. You get a style by painting a lot, and some of an artist's style comes from teachers. Worry more about learning everything and anything, and don't do things only one way. Painting is a creative process, so keep an open mind.

EXERCISE

A good way to study different styles of composition is to visit your local art museum or library. Paint a copy of the works you admire. Copying a master's work gives you insight into what goes into painting a great work of art.

Easy Subject—Hard Subject

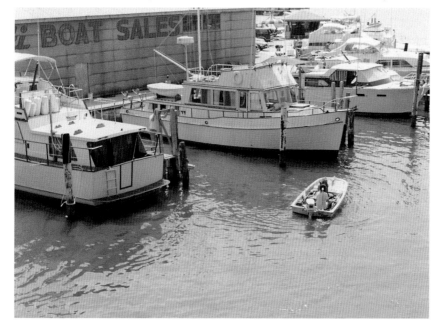

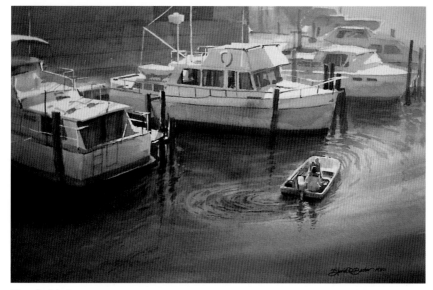

Kenosha Marina
Arches 300-lb. (640gsm) rough paper
14″×21″ (36cm×53cm)
Collection of Carol A. Kelly

Hard to Easy

A seemingly hard subject instantly turns easy when you look at the big picture. Simplify the large value masses to hold the painting together. After the large masses are in place, you can go crazy with detail. Don't look at the picture as specific objects, like a boat, a building, water, figures or the sky; instead, think of the objects as shapes constructed together to make a composition. If you think of each object separately then you paint that way, each object one at a time. This makes the painting stiff and the composition and value pattern usually don't hold together. Squint your eyes so you don't see the detail.

TIP

The more preplanning you do before you paint, the better the chances of creating a good painting.

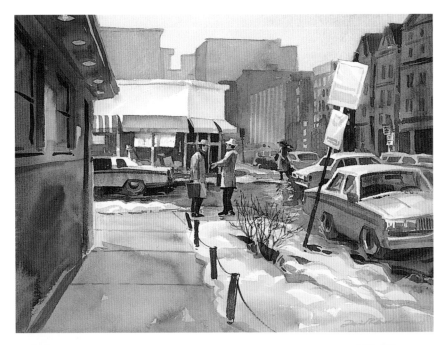

This painting may look simple, until you look at the photograph here which reveals a very intense layout. Remember to simplify and you'll make any difficult subject work no matter how tough it seems.

Wellington
Arches 300-lb. (640gsm) rough-paper
14″×18″ (36cm×46cm)

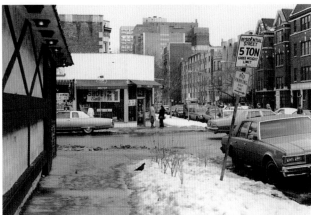

First, I made a black-and-white photocopy of the reference photo for "Wellington," which simplified all the objects to value masses. Then I did a value sketch and brought the figures forward to give the picture a better center of interest.

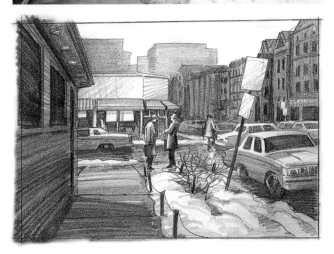

Find Subjects Everywhere

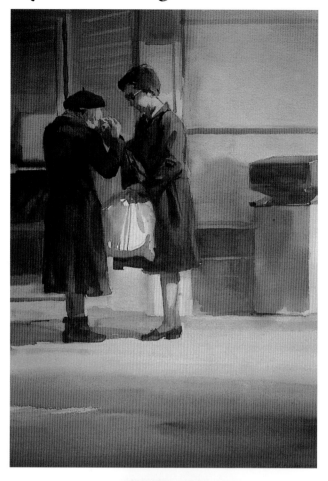

Be Prepared

Buy a disposable camera and keep it with you at all times. Disposables take good enough pictures and are small, so you won't look like a tourist everywhere you go. You never know when you're going to run into the greatest picture and without a camera the moment will pass. You'll kick yourself every time you think of that painting that could have been. Believe me, I speak from experience. I've missed some of the best shots. I have learned from my mistakes, however, and this painting is the result of one of those times when I did have a camera in my car's glove box. I now keep a disposable camera in my car, my paintbox, my briefcase and one in my winter coat. I think I'm covered.

Ladies at K-mart
Arches 140-lb. (300gsm) cold-press paper
15″ × 11″ (38cm × 28cm)

Keep Your Eyes Open

I spotted this view while sitting in a dentist's X-ray chair. I didn't have a camera with me, so I asked if I could take pictures the next time I visited. Always be on the lookout for a good reference.

TIP

Take time to go driving some weekend and just shoot photographic reference for painting. Plan the days so you're not frantically driving around, looking aimlessly.

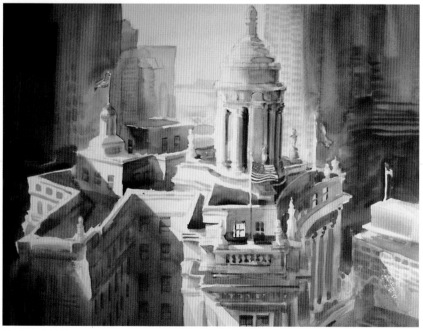

Dr. Wright's View
Arches 300-lb. (640gsm) cold-press paper
14″ × 18″ (36cm × 46cm)

Try This

Here's a great exercise to prove you don't need to travel to the ends of the planet to get the perfect picture. Take a small watercolor sketch pad or a camera and find a spot in your neighborhood or a familiar place. Look through the viewfinder or frame the shot by putting your thumbs together, extending your fingers upward (to form the sides of the shot) and holding a pencil between your fingers to form the top. (Also see "Make a Viewfinder," p. 67.) Now snap the camera or do a small pencil or watercolor sketch. Rotate ninety degrees and come up with another sketch. Do this until you've turned all the way around. This exercise helps you look at subject matter in a new light. The three reference photos and sketches here were done this way. I sketched on location, but also took the photos so I'd have a recorded image back in my studio.

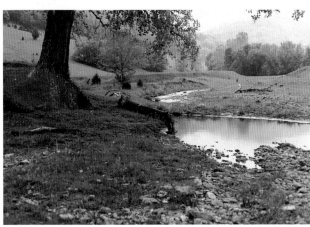
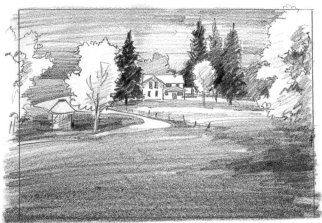

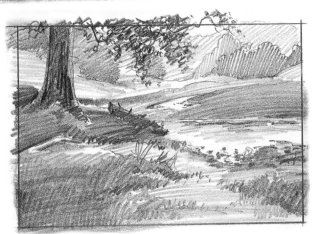

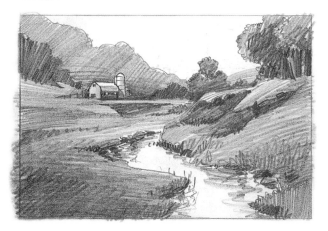

Trees Are Not Just Filler

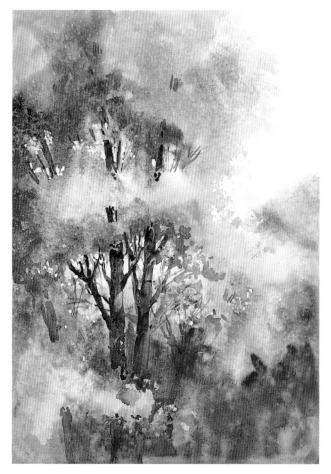

Study Trees

Don't put trees in your paintings just to fill an empty space. Trees and grasses are as important as any other element in the composition. Learn to draw trees and grasses by going outdoors and studying them. Then practice to make them look real—don't use meaningless brushstrokes. Paint with authority but don't be afraid to make mistakes. You learn by fixing the mistakes.

Fall Colors
Strathmore Crescent 112 rough board
13″×19″ (33cm×48cm)

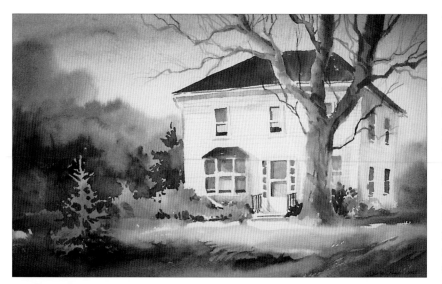

Pine Tree and House
Arches 300-lb. (640gsm) rough paper
13″×21″ (33cm×53cm)

Don't Paint Every Leaf

There's no need to paint in every leaf on a tree unless you're doing a study of trees to be printed in a reference book, but please don't think a simple whisking motion of your brush makes a tree. When detailing any subject, apply most of the detail to the center of interest. Detailing everything in a painting flattens the image. Paintings need a balance of soft and hard edges, detailed and blurred areas.

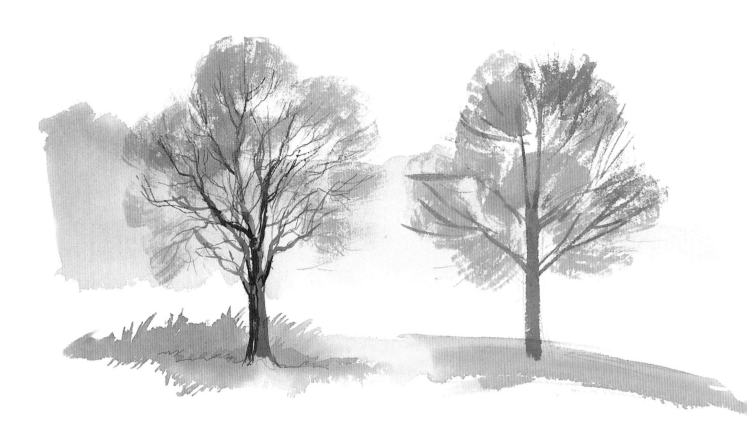

Right way

Wrong way

Paint Trees as Studies

When learning to paint trees, it's important to practice sketching them. Do them as studies not as finished paintings. Take your time and plan out the drawing and composition. Then do a good drawing onto your watercolor paper and a clean painting of the tree. Be constant with the way you paint and as clean as possible.

EXERCISE

Houseplants make great reference material for practice. While sitting in your recliner, take out a sketch pad and do a couple of value sketches of flowers or plants close by. If you don't have any houseplants, it's a good excuse to get a few. Get fake plants if you don't have time to water.

Paint Trees Step by Step

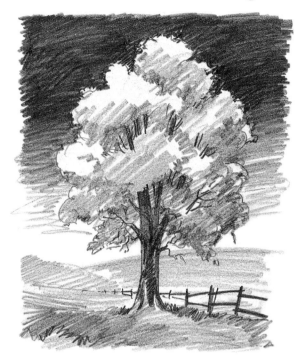

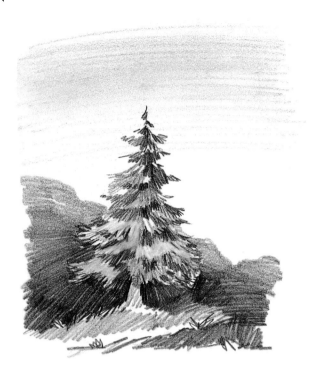

1 Do a quick value or thumbnail sketch first, even if the painting is just for practice. Notice here how one of the studies is opposite in the light and dark pattern from the other. The one on the left has light leaves surrounded by a dark blue intense sky, while the dark pine tree is against a light sky. It's a good idea to use opposite values to create negative painting.

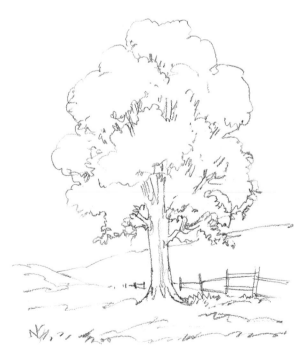

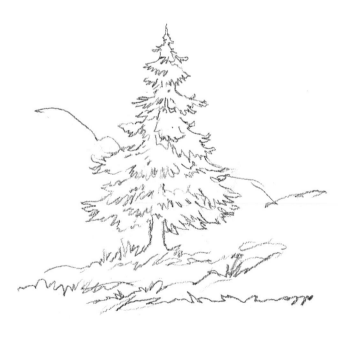

2 Next do a pencil sketch on the watercolor paper consisting only of line work. This line drawing, which should be very accurate, is what you'll use to paint on when actually painting the tree.

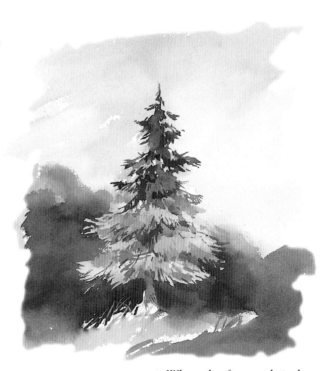

3 The first watercolor wash is for the lights in the foliage and sky.

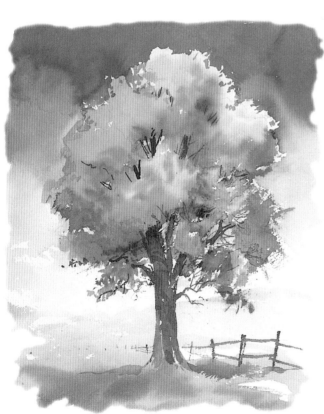

4 When the first wash is dry, go back in and paint blue around the foliage of the tree, instantly creating negative painting. For the pine tree use a dark green and paint the dark branches right over the light background sky wash.

The Still Life

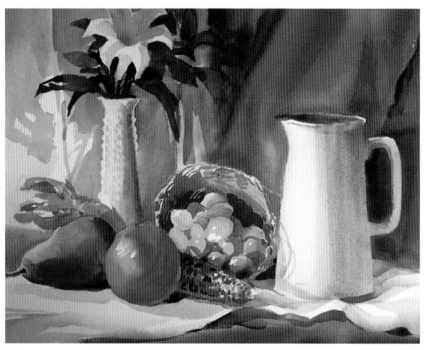

Harvest
Arches 300-lb. (640gsm) rough paper
14″ × 18″ (36cm × 46cm)

Think of a Value Sketch

Setting up a still life is like doing a preliminary value sketch. First pick a center of interest. It can be a particular object or an interesting area of the still life, but be sure it is off-center. In "Harvest" I made the fruit the center of interest and made sure the colors of the fruit were more vibrant than anything else in the painting. Squint your eyes at the painting and you'll notice that the pattern of light goes from the white flower down the vase, around the bottom of the fruit and up the pitcher. Everything else makes up the dark pattern. When composing patterns of light and dark, it doesn't matter how many objects are in each pattern, just that the light and dark patterns are simplified and are large.

TIP

Here's a quick still-life composition checklist:
- Pick a center of interest.
- Place less interesting, smaller or less vibrant objects next to the center of interest. Balance the setup so it doesn't seem lopsided.
- Use an odd number of objects that are different sizes. Variety is an important spice of composition.
- Light the still life so there are well-composed areas of light and dark. Keep most of the contrasted lighting in the center of interest.
- Take time with your setup. It's just as, or even more, important as actually painting.

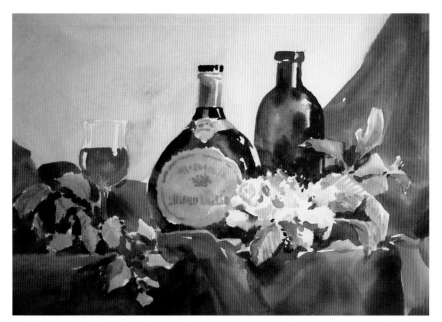

Red Wine
Strathmore Crescent 114 cold-press board
10″×14″ (25cm×36cm)

"Red Wine" was set up with an overcast lighting, making the value of the colors form the pattern rather than having the shadows form the light and dark pattern. Complementary colors of red and green along with overlapping objects create the depth in this painting.

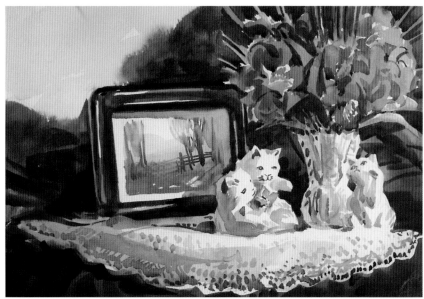

Cats
Strathmore Crescent 112 rough board
9″×14″ (23cm×36cm)

Using lettering or lively objects like the porcelain cats in this painting is an excellent way to create a center of interest, because subconsciously your vision automatically sees such objects and lettering before other objects.

Scenes of the City

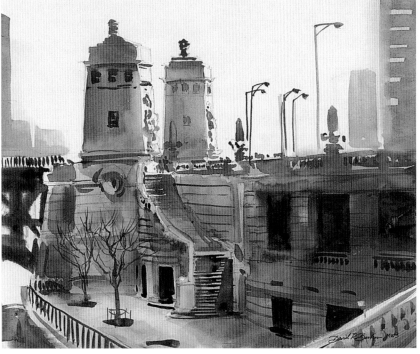

Michigan Avenue Towers
Arches 300-lb. (640gsm) cold-press paper
10″×12″ (25cm×30cm)

Simplify

Don't shy away from city scenes because you feel they are too busy or hard to draw. Simplify and break down the planes into large value patterns. High-rises may have thousands of windows, but you don't have to paint every one of them. The trick is to focus in on the center of interest and reduce the focus as you work away from it. Paint parts of the city, for instance a storefront or maybe even just a window with a flowerpot in it.

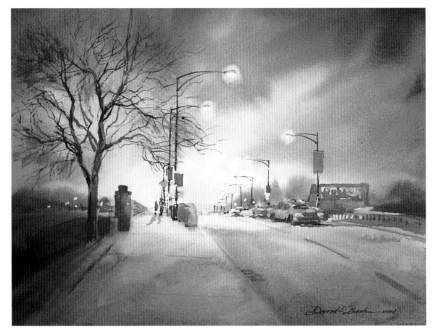

Monroe to the Goodman
Arches 300-lb. (640gsm) rough paper
10″×14″ (25cm×36cm)

Lighting is Important

Lighting is very important to the mood of any picture. This scene on a sunny noonday may not be as effective as in the lighting here. Search for good reference at all times, be it early morning to late at night, from rainy days to blizzards. When you've found a winning location, sketch and photograph it in many different lighting and weather situations. Get all you can out of a good location.

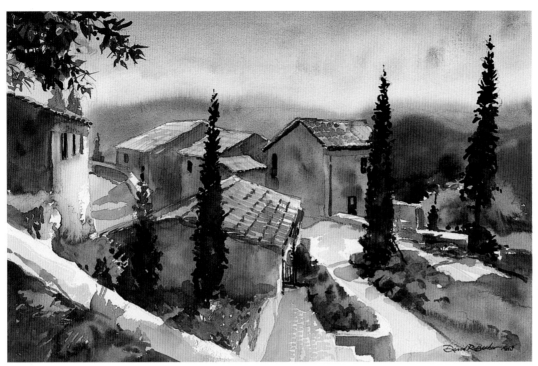

Hillside
Arches 300-lb. (640gsm) rough paper
14″×21″ (36cm×53cm)

An urban location isn't always a city like Chicago, New York or Los Angeles. It could mean a small town in rural America or even a back-road town in Italy.

TIP

If you want some great public exposure, set yourself up on a street corner in the middle of the city. The last time I did this, a photographer from the *Chicago Sun-Times* stopped his car, jumped out and took about ten shots. He told me to look in Monday's paper. Sure enough my picture was in the paper. If you're hesitant to paint in front of people, just go to the spot a few days before and take a couple of photos. Then start the painting in your studio and finish the detail on the spot. No one will ever know. Don't forget to bring business cards.

Paint Small Sketches Anywhere

Practice and Paint

The advice I always give to someone who wants to become a good artist is: practice and paint. It seems we never have enough time for the single most important thing we would love to be doing every second of the day. Get into a routine and think about painting wherever you are. The trick is to carry a small sketchbook with you at all times. As you can see here, I go as far as to carry a paintbox with me on my commute to and from work.

The sketches on these two pages were done during my commute which takes about an hour. The sketches are never smaller than 5″×7″ (13cm×18cm) or larger than 8″×10″ (20cm×25cm). My goal is to finish one each trip. This kind of plan keeps you focused on the exercise and keeps it fresh.

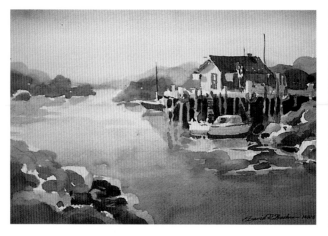

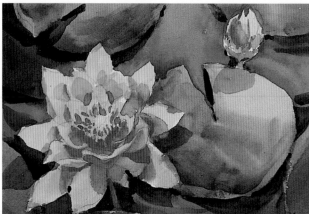

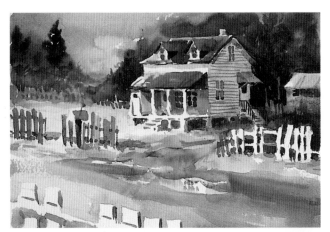

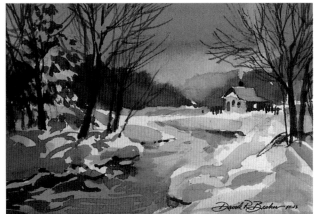

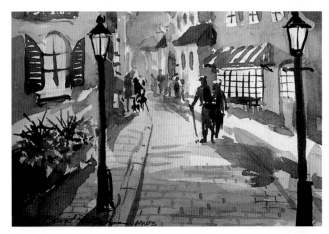

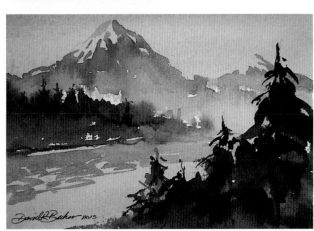

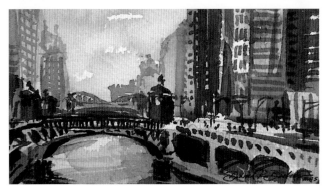

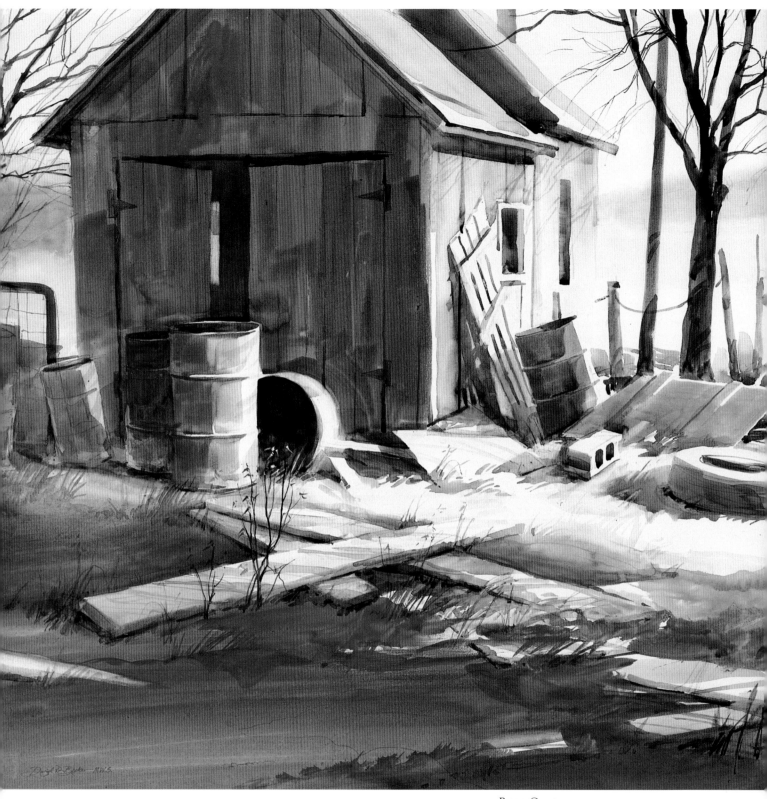

Brown County
Strathmore 5-ply bristol board
22″×28″ (56cm×71cm)

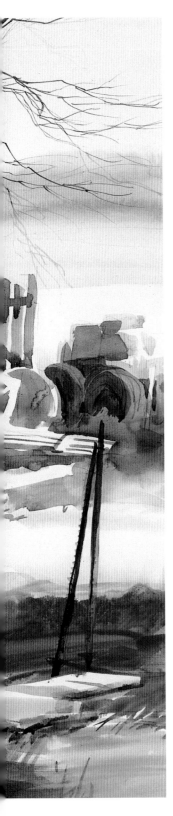

The Blueprint

A carpenter doesn't build a house without a blueprint, and a watercolorist shouldn't attempt a painting without a preliminary value sketch. All creations should be done with a plan of attack. The sooner you realize the importance of a planned value sketch, the sooner you'll become a skilled watercolorist.

Do value sketches! If you were allowed to read only one chapter in this book, this would be the chapter I'd recommend. Nothing is more important than planning how the painting will be composed.

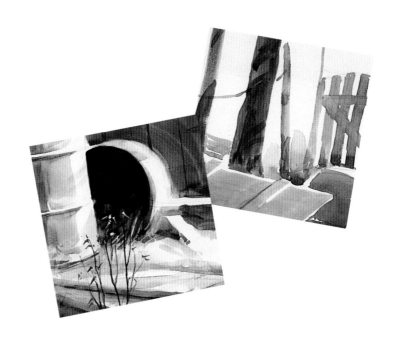

The Value Sketch

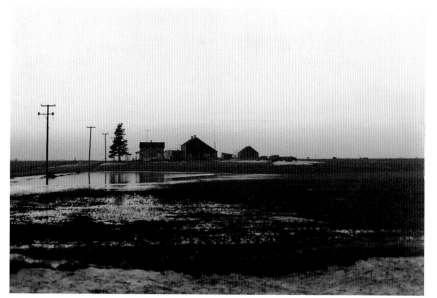

Use Your Pencil

A blueprint is to a house as a value sketch is to a painting. A value sketch is like going through the motions of doing the actual painting. Pretend the pencil is your brush and put in the values. Value sketches help simplify the composition and allow you to figure out the process you'll take when painting the picture. You must intentionally turn busy photos into simple value sketches, but even if the layout in the photo seems simple, you still should do a value sketch. You can always create something better than the photograph.

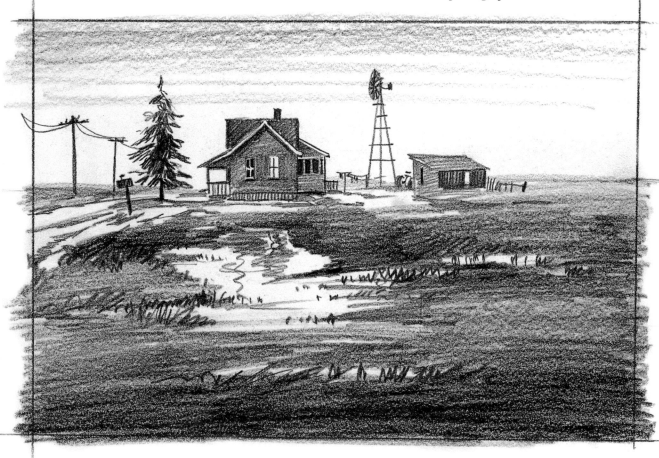

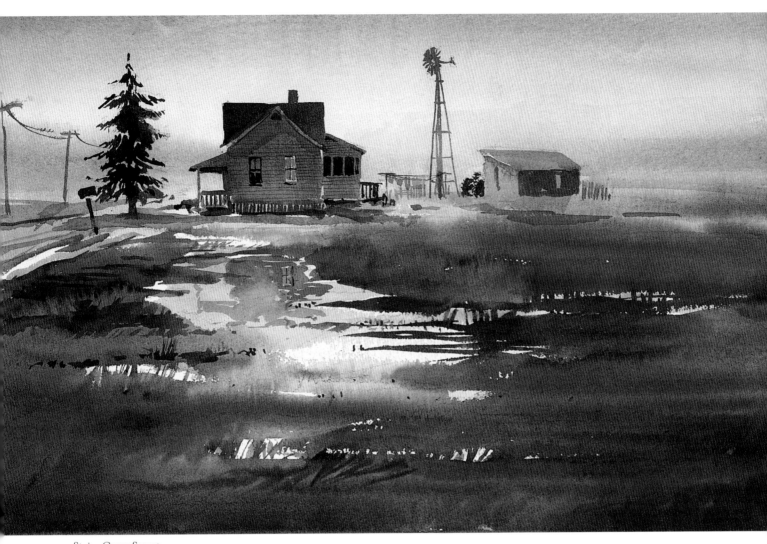

Spring Grove Sunset
Arches 300-lb. (640gsm) rough paper
14″ × 22″ (36cm × 56cm)

This painting was painted in about forty minutes because the value sketch was already worked out. Usually the painting time is shorter than the planning time. Make the preliminary value sketch a procedure you do every time you start a painting. After a few paintings it becomes routine and you'll feel lost without it.

TIP

Don't draw a value sketch too large: 5″ × 7″ (13cm × 18cm) is about the biggest you'll want to get. The value sketch is not intended to be a finished work of art, but a plan of attack.

Boundaries

The boundaries of your painting or sketch are the dimensions you'll be working within. When you're working out your value sketch, the first thing you should draw is a rectangle or square to frame the area you'll be working in. Then draw an imaginary line from corner to corner to indicate where the center of the picture is. I've shown the lines in the middle drawing on this page. This gives you a rough idea of where the objects fall in relation to the center of the picture. Make sure the size of the pencil sketch is the same proportions as the photo.

Next look for the big angles, like the angle on the middle child that runs from the left shoulder to her feet. Look how the angle almost intersects the middle of the picture. Now look for all the the other big angles, like the horizontal lines that run from the top of the one child's head to the other. All these angles help you when you draw the lines into the boundaries of the value sketch and then onto the watercolor paper. Drawing pencil sketches from photos or from life is one of the most important ways to learn the skill of drawing and composition. It's similar to a musician practicing the scale.

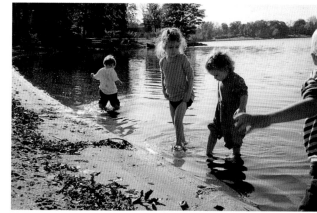

Photograph

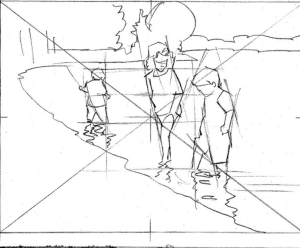

Line Drawing

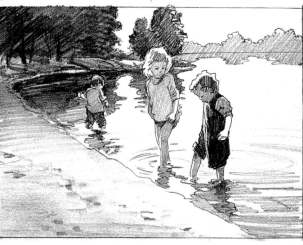

Value Sketch

TIP

Learn to paint within boundaries of standard framing size. You'll save a fortune in custom framing charges.

If you don't work into a boundary, then you are doing a vignette. A vignette is a picture that bleeds to the white of the paper before reaching the edge of the picture boundaries, as illustrated in this painting.

> **TIP**
>
> Don't try to sketch a rectangular value sketch onto a square sheet of watercolor paper—use a proportional rectangular format. When the boundaries and proportions of your sketch and painting are different, the preliminary drawing on the watercolor paper will look squeezed or too elongated, ruining the composition of the value sketch.

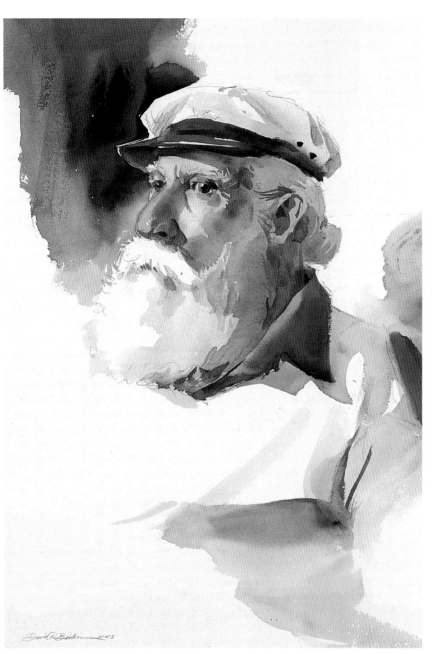

Jack
Arches 300-lb. (640gsm) rough paper
14″ × 21″ (36cm × 53cm)

Thumbnail Sketch

Keep It Loose and Small

A thumbnail sketch is a small drawing of the composition and value pattern without any fine, detailed drawing. It shouldn't be any larger than about two inches wide. Thumbnails are like value sketches only a little smaller and rougher. Use them to figure out how you want to place your value pattern into a specific space or boundary. I recommend you do a thumbnail when painting from life, like a model, a still life or a landscape.

> **TIP**
>
> When painting a still life or figure drawing, arrange the live setup as though it were a value sketch. Then do a small thumbnail sketch to figure out your placement, dimension and proportions of the drawing to correspond with your painting surface. The small sketch gives you an idea of the boundaries you will be working in.

Begin With One Color

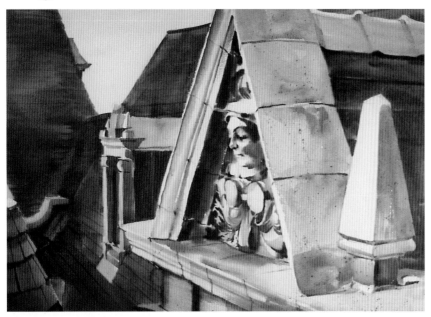

Castle Roof
Strathmore Crescent 112 rough board
11″×16″ (28cm×41cm)

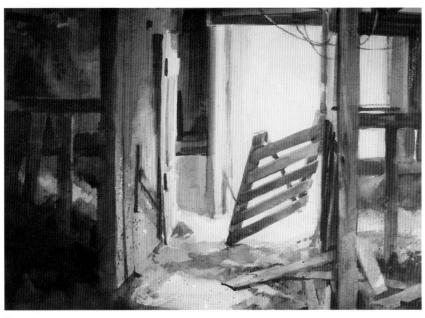

Barn Gate
Strathmore Crescent 112 rough board
11″×15″ (28cm×38cm)

Take Time

Take time to get acquainted with the medium of watercolor and how it handles before you jump into using full color. Try a one-color painting using a dark hue. This gives you a full range of value since the paper is white. Focus on the composition, values and edges first. If you get bored after doing a lot of one-color studies, go ahead and do a painting in full color. Painting should be fun, so never allow yourself to get so frustrated or bored that you quit. After you do a couple of fun paintings, go back to one color until you feel you know what you're doing. Then, slowly add another color to your palette after each painting.

Use Value, Not Lines

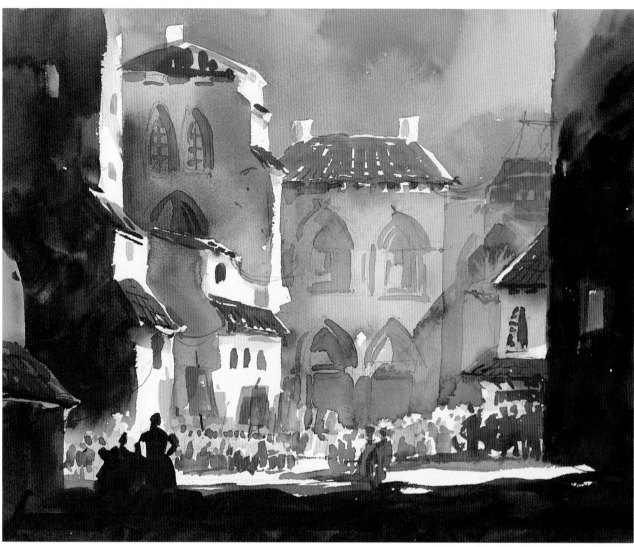

Illustrator Copy
Arches 140-lb. (300gsm) rough paper
12″ × 15″ (30cm × 38cm)

Make the Lines Disappear

There should be no lines in watercolor unless something is physically a line, for instance a telephone line or the ropes on a sailboat. Use value changes to show the edge of an object, not a line. The pencil line you first apply to your watercolor paper should disappear when you cover each side of the line with a different value, which in turn shows dimension. Show edges and shapes by placing different shades of value masses next to each other, rather than using lines to show where a corner is located or the shape of an object.

Let's use a building as an example.

Problem: When painting a roof that looks approximately the same value and close to the same color as the sky, don't try to separate the shape of the roof from the sky with a line.

Solution: When faced with two objects of the same value, change one of the values to make it either lighter or darker. Changing color and intensity is also a solution, but learn to work with values first.

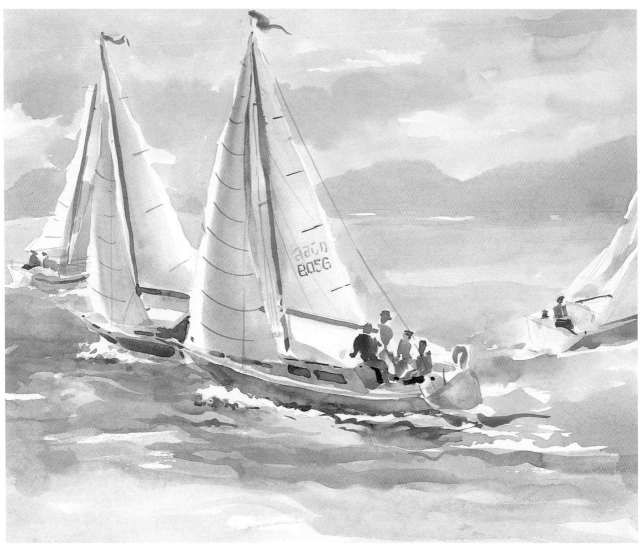

Sailing Away
Strathmore Crescent 114 cold-press board
15″ × 19″ (38cm × 48cm)

Here's an example of a high-key painting where the pencil lines were darker than most of the painting. Just erase them after the painting is finished if this happens. In a high-key painting most of the values are light and closely related. Only parts of the center of interest might have darks. It's a very effective way of painting, but harder to accomplish compared to using a full value range.

TIP

Here's a good exercise to practice using value rather than line. Take a children's coloring book and place a sheet of tracing paper over a page. Use pencil, marker or crayons to apply values in the lines that show through the tracing paper. Treat the drawing as if you're doing a value sketch. After you complete the coloring, remove the tracing paper to see if the picture holds together without the lines showing through. If the values don't hold the picture together and you can't tell what it is, then practice until it does hold together.

Center of Interest

Eye Magnets

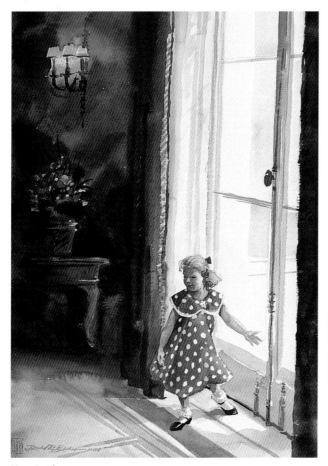

TIP

Here are some guidelines to help you achieve a good center of interest, which makes for a good painting.
1. The center of interest should be the reason you are painting the picture.
2. The center or area of interest should be at least one-third of the picture.
3. The center of interest should have the most detail. It should have the most contrast of anything in the painting and the most intense color of the painting. To achieve contrast for the center of interest, put the darkest dark next to the lightest light including hard edges.
4. Finding the center of interest is like looking through a camera lens, focusing on an area and letting the rest of the picture blur.
5. People and lettering are instant eye-catchers and an easy way to achieve a center of interest.

Tara Inside
Arches 300-lb. (640gsm) rough paper
13″ × 18″ (33cm × 46cm)

The human form and lettering in a painting automatically become an eye magnet.

Problem: The viewer will subconsciously look at human figures and lettering first before looking at anything else.

Solution: If lettering or figures aren't your intended center of interest, downplay them by using less contrast and color. If lettering and/or figures are your center of interest, use colors that are more vibrant and have more contrast than anything else in the painting.

Placement for the center of interest is illustrated in this graph. It should fall into one of the four circled areas indicated.

An Area, Not Object

Many times the center of interest isn't a single object but an area of the painting that stands out. For instance, the center of interest in "Blue Mountain" is really more an area that has more contrast, is harder-edged and a little more colorful than the rest of the painting.

Blue Mountains
Strathmore Crescent 112 rough board
9″ × 15″ (23cm × 38cm)

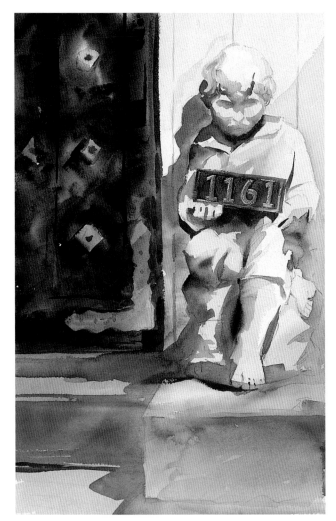

Avoid the Face

The center of interest in a portrait can be a section of the face, like an eye or a side of the face.

Problem: When you paint an entire body, the face is usually what a viewer automatically looks at first.

Solution: Again, this is a subconscious reaction. The only way to steer the viewer away from seeing the face first is to use less contrast and color around the face and heighten the color and contrast somewhere else in the painting.

Address Sculpture
Arches 300-lb. (640gsm) rough paper
13″ × 21″ (33cm × 53cm)

Vertical Format

When you paint a vertical format painting, especially a landscape, be aware of your center of interest. If you place it at the top of the paper, the painting can lose its dimension and become top heavy. This happens because the center of interest usually has the hardest edges, the most contrast and the most vibrant colors which bring the background forward.

When you place the center of interest in the background or upper part of a vertical painting and the background comes forward, you need to decide between good dimension and good composition. Go with composition, because good dimension without good composition doesn't work, but good composition works well enough, even with incorrect dimension.

> ### TIP
>
> The object or area of interest should stand out against the rest of the painting. Don't give everything in the painting equal importance. If everything has the same feel and importance, it makes for a stiff and unexciting painting, and visually the viewer doesn't get a smooth-flowing tour.

Max's Pond
Arches 300-lb. rough (640gsm) paper
14″ × 20″ (36cm × 51cm)

Compose From Photographs

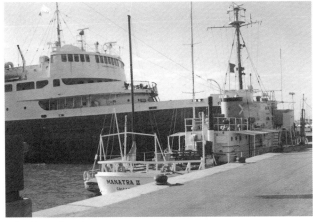

Photo
Don't rely on a photograph of an outdoor subject to give you correct color or perspective. To capture what is realistic in nature, you need to experience your subject firsthand. You need to witness the real thing, on the spot.

Black-and-White Copy
When a photo is busy with subject matter, make a black-and-white photocopy of it. This eliminates the color and detail and the large value masses. Working from a black-and-white copy also helps you avoid trying to duplicate the colors in the photo. Artists shouldn't copy, they should create.

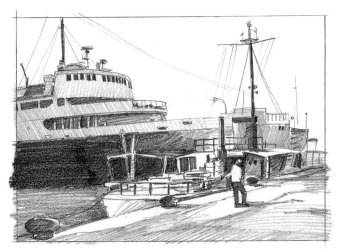

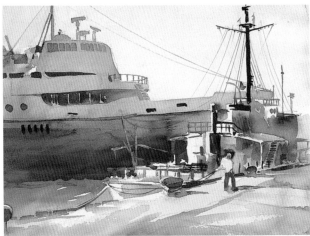

Value Sketch
Work out your value sketch from the black-and-white copy. Here I've added a figure to give the composition more life.

Finished Painting

Navy Pier
Arches 300-lb.
(640gsm) rough paper
10″×14″
(25cm×36cm)

Compose From Life

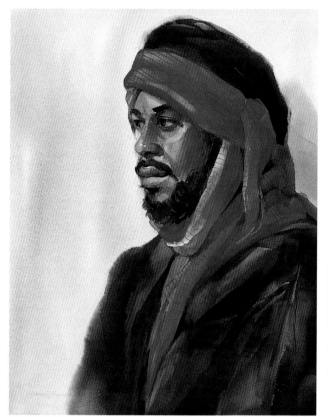

Greg
Arches 300-lb. (640gsm) rough paper
17″×22″ (43cm×56cm)

Study Your Subject

Painting from life, such as painting the figure using a model, painting on location or painting a still life, provides knowledge and experience that can't be equaled by just using photos. When working from life, make sure you study everything about the subject. Look and try to remember every minute detail you can. Use a photo only as a reminder of what you saw in real life.

> **TIP**
> Work from both photographs and life. Combine them and you'll pick up the best of both worlds.

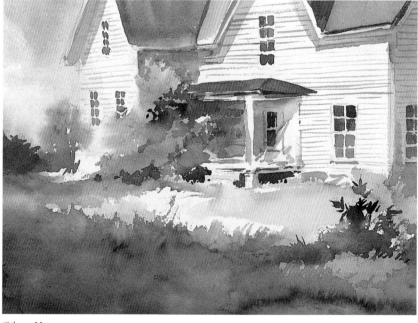

Gilmer House
Arches 300-lb. (640gsm) rough paper
10″×14″ (25cm×36cm)

Changing Light

Problem: While composing from life outdoors, keep in mind that the sun will be moving and constantly changing the shadows in your painting. These changes can ruin your value pattern and, in turn, ruin your composition.

Solution: Do a small thumbnail sketch or quick value sketch. Follow the sketch to keep your pattern and composition the same even though the light changes. Once you commit to the sketch, don't change anything, even if the light changes.

Simplify When Painting Outdoors

Problem: Many artists try to put in every detail when painting outdoors because the human eye focuses on objects individually. So, in turn, everthing looks in focus creating an overwhelming amount of subject matter.

Solution: Think like a camera. If objects are not in the center of interest, put them out of focus.

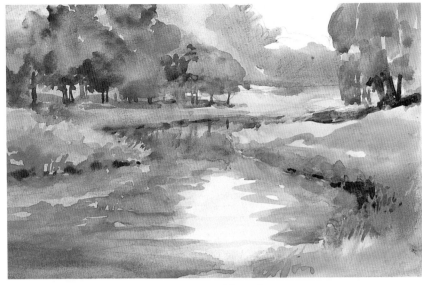

Morton I
Arches 300-lb. (640gsm) cold-press paper
9″ × 14″ (23cm × 36cm)

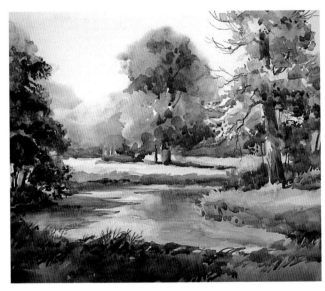

Morton II
Arches 300-lb. (640gsm) cold-press paper
12″ × 14″ (30cm × 36cm)

Make a Viewfinder

When working from life, make yourself a viewfinder out of an old slide or create a square with your fingers. Extend the viewfinder out in front of your eyes until the subject is framed and you're viewing a good composition. If you need to change a few things to improve the composition, go ahead and change them on your sketch. Just like when working from photos, don't think you have to paint the scene exactly as you see it.

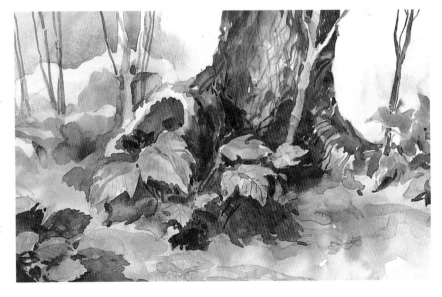

Leaves in the Woods
Arches 300-lb. (640gsm) rough paper
10″ × 15″ (25cm × 38cm)

Change, Simplify, Combine

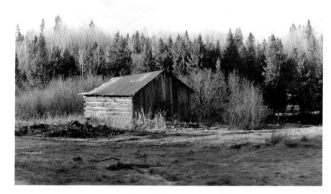

Change

When you work out a value sketch, always try to make it better than the photograph. The photo shown needs a change.

Problem: I decided the scene needed to be more dramatic. I also felt it had too many parallel lines and those lines were divided into three equal parts.

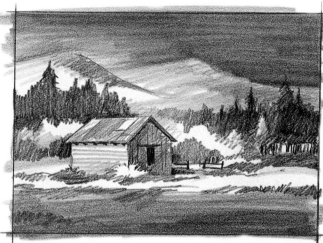

Solution: Look at the value sketch and see the mountains and dramatic lighting I added. This is a simple approach but effective. The photograph probably could have been painted exactly as is, but always try to make your painting better than the reference. If a sky needs to be yellow instead of blue, change it. If an object is a light value, but in your sketch it would be better dark, darken it. If you see a green tree, yet feel the composition calls for a light reddish, Burnt Sienna tree, then change it.

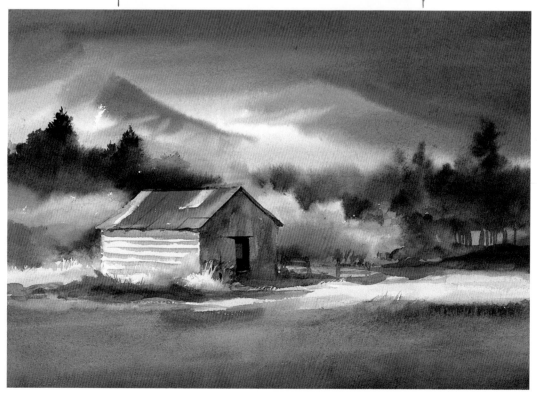

Mountains and the Shack
Arches 300-lb.
(640gsm) rough
paper
14"×21"
(36cm×53cm)

Donna and Alison
Arches 300-lb. (640gsm) rough paper
14″×15″ (36cm×38cm)
Collection of Donna Murawski

Simplify

Problem: I've noticed artists sometimes tighten up when painting human figures. There's also a tendency to paint the figure in pieces instead of thinking and painting large areas.

Solution: The only time you should ever paint in pieces or small parts is at the end of the painting, when finishing up the detail. Notice in "Donna and Alison" that a lot of detail in the figure has been left out. For example, the face of the figure in the back. You need to simplify shapes and value masses, so when you put detail in the center of interest, it stands out more than the area around it. You actually get more emotion and atmosphere by using less detail.

TIP

Always solve problems before you put paint to paper. You may have to drastically change a photo, combine photos, change lighting or just simplify the photo. As the creator, you must do whatever it takes to make the painting work.

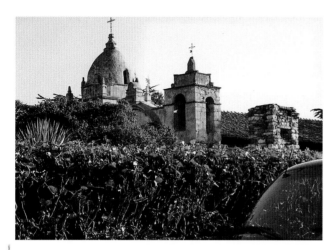

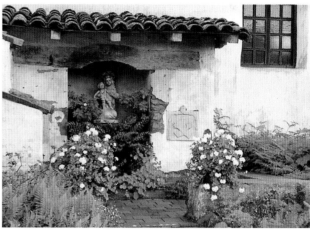

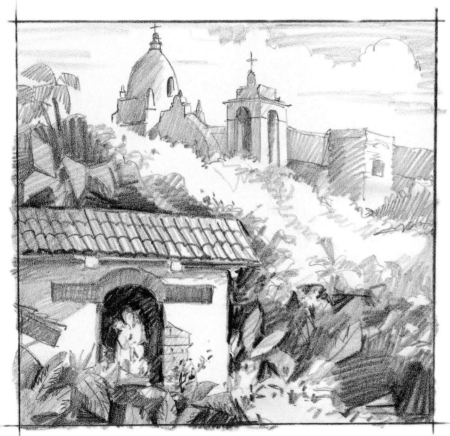

Combine

There are times when one photograph just isn't enough for a good composition, so combine photos to create a better composition. Both these photos are great, but combining them adds dimension to the composition.

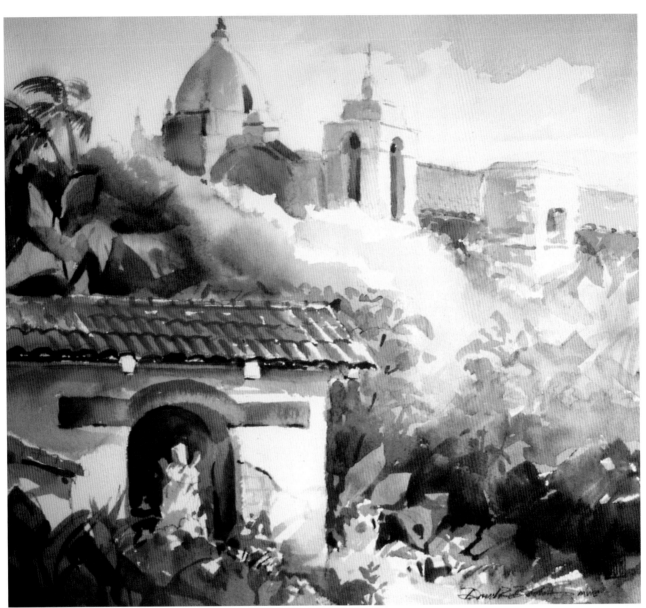

The painting "My Donna Chapel" uses all three principles, it changes, simplifies and combines.

My Donna Chapel
Arches 300-lb. (640gsm) rough paper
14″×17″ (36cm×43cm)
Collection of Donna Gerdy

TIP

If you get into a rut of always using the same colors in your paintings, tape over frequently used colors. This forces you to pick other colors from your palette when searching for the values you want.

DEMONSTRATION: *Complete A Value Sketch*

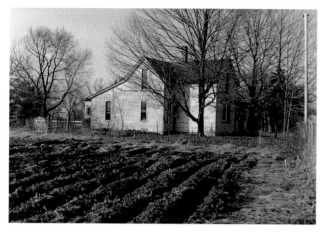

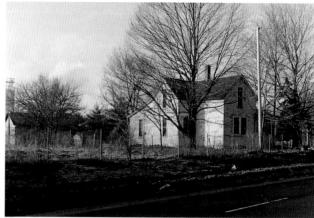

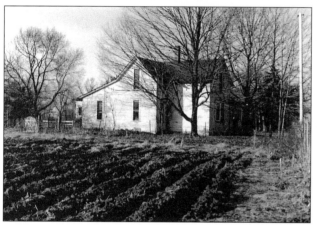

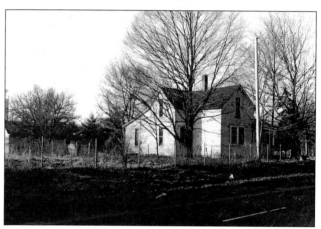

These two photographs do not show a good composition, so I'll demonstrate how to alter the composition when creating your value sketch. First, photocopy your color photos in black and white, so you can clearly see the value patterns.

EXERCISE

For quick practice in shading large areas on a value sketch, take a photograph and place tracing paper over it. Now just shade the large areas you can recognize through the tracing paper. Don't do this in place of a value sketch—it's just an exercise to help you see large areas and how to technically shade those areas. Real value sketches start with a line drawing that is composed correctly, then shaded.

1 Line Drawing

Figure out the boundary of your sketch out, then place marks to indicate halves of the paper and then quarters of the paper. This helps keep the proportions correct when you draw the pencil scene onto the watercolor paper later. Measure by eye and not with a ruler. A ruler makes your drawing look too mechanical and you won't learn how to measure with your eyes if you don't practice. Now do a line drawing of the picture to indicate exactly how objects are arranged in the boundary.

You'll notice I used the photo with the crop rows and put a more severe angle to the rows and the fence similar to the photo with the road. I also used the small building at the far left of the photo with the road. This adds weight to the left of the composition and stops the eye flow from running off the page.

The center of interest is obviously the house, but to make it stand out, I added water to the crop rows so I could reflect the house in it. Also the dark tree against the house brings contrast to the center of interest.

2 Large Masses

Use a pencil with a soft lead and fill in the largest masses with values. Use the pencil like a brush. At this stage try not to get too detailed—stick with the large value masses. The large masses of value in this sketch are the sky, the crop rows, the distant hills and the roof and shadows on the house. The dark trees aren't indicated as a dark mass yet, because they'll be used as the second wash to carve out negative painting. Notice that all the

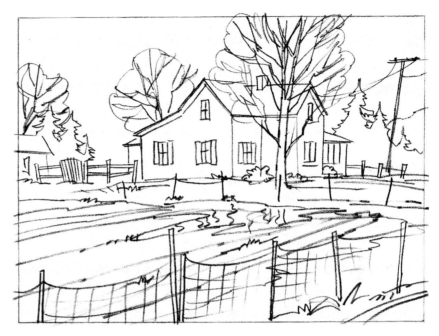

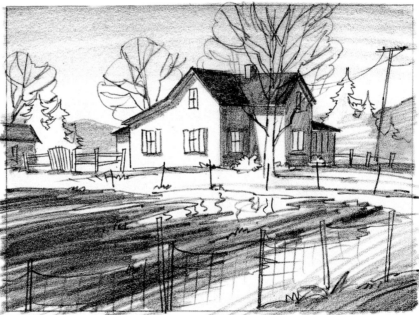

branches aren't drawn in, only the most prominent ones. The pencil line around the outer shape of the trees indicates how far out from the branches you'll apply paint.

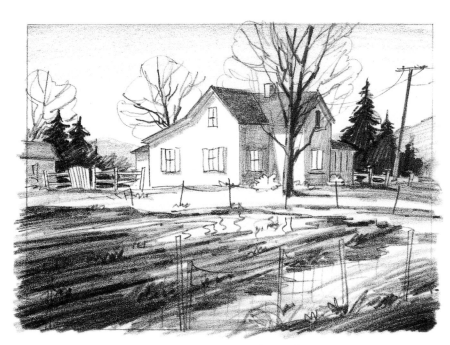

3 Darks
Carve around the light objects with a darker value to create negative painting. For instance, the dark pine trees here are a good example of negative painting. Notice that by placing the dark trees behind light objects you create the white fence, the gate and part of the telephone pole and identify the edges of the buildings. Use negative painting as much as possible. It's a great way to show dimension.

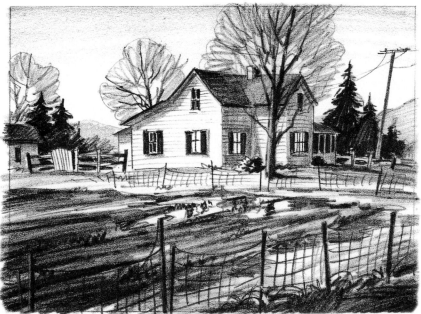

4 Detail
Put in the detail and finishing touches. This finished sketch is a little more detailed than the ones I usually do, but remember the more detail you put into your sketch, the easier the painting will be.

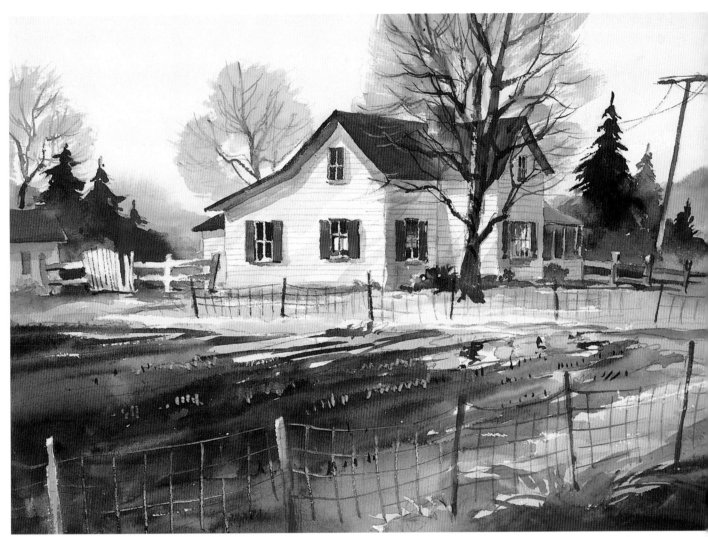

Re-create the painting to correspond with the value sketch. If small parts are a little different from the value sketch, it's okay, but if large values and masses are ignored, you'll have trouble with your finished painting.

Brown County Street
Arches 300-lb. (640gsm) rough paper
13″×18″ (33cm×46cm)

TIP

I'm not a proponent of using an opaque projector to help sketch your photo to watercolor paper. If, however, you feel you really need to use the projector, then project your value sketch image onto the painting surface. This way you're copying something you drew and composed, instead of a photograph that may end up looking stiff and not composed well.

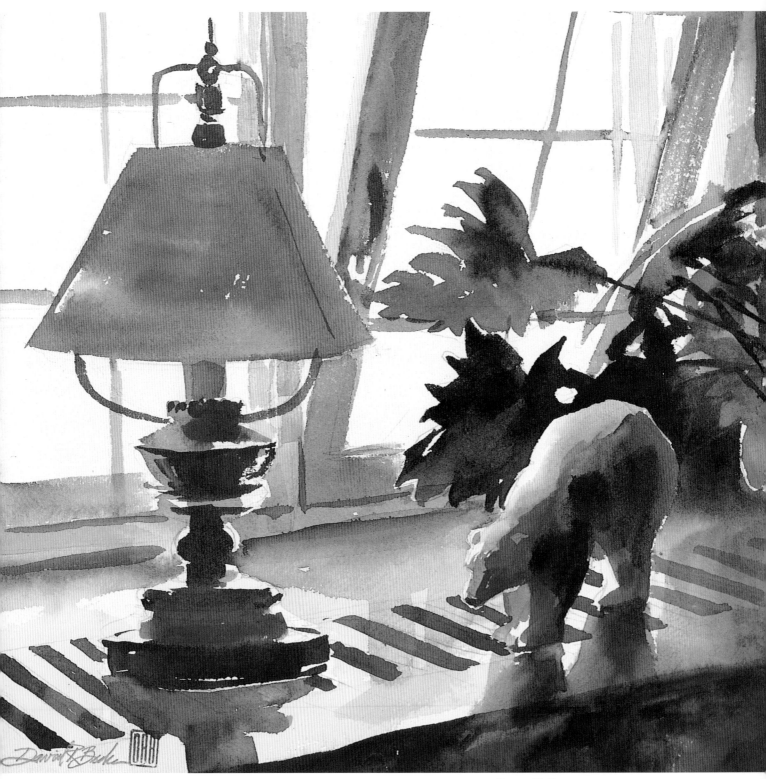

Bear on Shelf
Arches 300-lb. (640gsm) rough paper
13.5″×18″ (34cm×46cm)
Collection of Alison Finnegan

5 Getting Into Dimensions

Many times the scariest part of doing a painting is starting it—putting the first brushstroke of color onto a sheet of watercolor paper. It scares us because we realize we have to turn a flat, white sheet of paper into a two-dimensional painting. At first it may seem an impossible task, but if you just think of a painting as having a foreground, a middle ground and a background, it will make it seem more manageable. The elements you'll combine to achieve the look of dimension are: overlapping, hard and soft edges, perspective and color.

Ways to Show Dimension

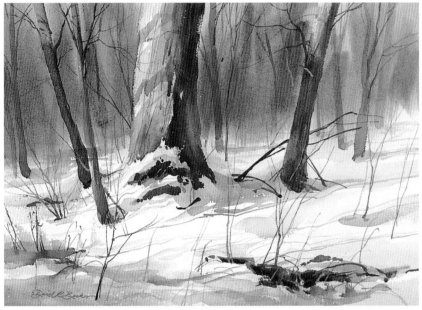

Mom's Backyard Trees
Arches 300-lb. (640gsm) rough paper
14″ × 20″ (36cm × 51cm)

First There are Planes

When I refer to dimensions as layered masses, I'll use the term "planes." Planes make up the dimension of your painting. A basic painting has three planes: a foreground, a middle ground and a background. A larger plane can also have smaller planes inside it, giving that plane yet another dimension.

Keep dimensions simple as in the painting here. The center of interest, in the middle ground, is detailed and harder-edged than the rest of the painting. The background is blurred and soft-edged. The foreground material overlaps the background. Most paintings should be like this. If your paintings aren't, then simplify the composition and value pattern.

Four Ways

Edges, color, overlapping and perspective make a painting two-dimensional. Think about these elements when creating a painting. Every composition, no matter what the subject, will have at least one of these elements. Each one is effective by itself and simple to achieve. When combinations of these are orchestrated correctly, a painting will have a two-dimensional look that is very effective. Paint these four cubes for practice to show the elements of dimension.

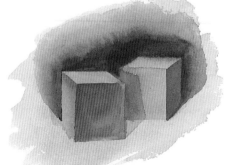

overlap

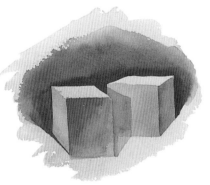

color and overlap

hard and soft edges, color and overlap

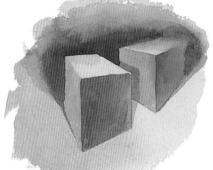

perspective, hard and soft edges, color and overlap

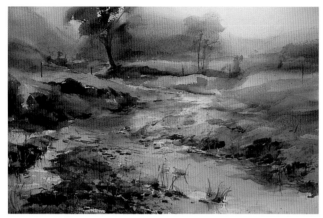

La Crosse Creek
Arches 300-lb. (640gsm) rough paper
14″×20″ (36cm×51cm)

In this painting I used overcast lighting to show mood, so I decided to use overlapping objects, color and aerial perspective for dimension. The center of interest is the large tree and areas surrounding it. This area should visually have the most contrast and the most vibrant color. Aerial perspective came into play by using the blurred, less vibrant trees and shrubs in the background. Since the painting is overcast, I used the local color of the objects, like the green grasses and trees, to make a patterned composition. Do this by making the objects each a basic value and then pattern them to form large planes. For instance, the background trees in this painting are in the background plane.

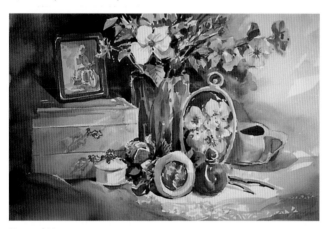

Personal Vanity
Arches 300-lb. (640gsm) rough paper
14″×17″ (36cm×43cm)

Overlapping and edge control are important when giving dimension to a still life. The center of interest here is not just one object, but an area—all the small objects clustered next to each other. These objects must have the most contrast, the hardest edges and the most color. Then to show dimension, overlap as many of the objects in the scene as possible. Also try to soften the edges of the background as much as possible. Use less intense colors in the background.

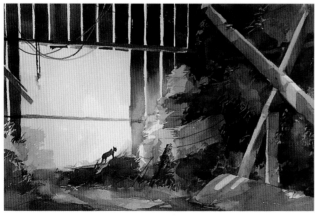

Cat's Barn
Arches 140-lb. (300gsm) rough paper
14″×19″ (36cm×48cm)

This painting relies on the light and dark pattern to show good composition. I used a silhouette to show a good light and dark pattern, leaving the dimension showing only two planes—the dark interior of the barn, including the cat, and the light exterior of the barn. This is an easy way to show the center of interest, sort of a bull's-eye effect. The light door opening is surrounded by darks, and by placing a dark object with an interesting outline against the light, you instantly create a center of interest. In this case, it's the dark cat and the light opening it's standing in.

Overlap for Dimension

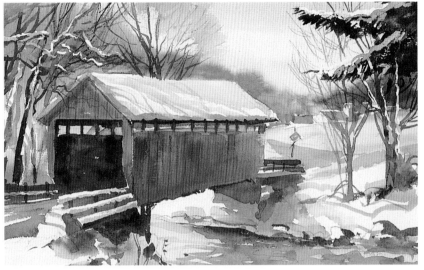

At the Chicago Locks
Strathmore Crescent 114 cold-press board
9″ × 15″ (23cm × 38cm)
Collection of Carol A. Kelly

Simple Overlap

Place one object in front of another, covering up parts of the object in back, to instantly create a foreground and a background as shown here.

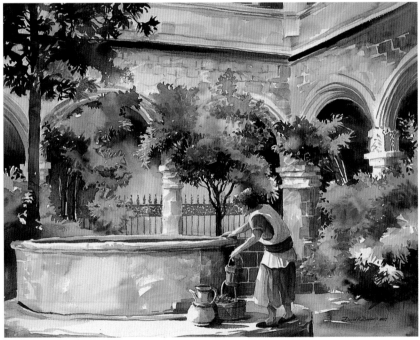

Watering Hole
Arches 300-lb. (640gsm) rough paper
22″ × 28″ (56cm × 71cm)

In this painting the dimensions are again created by objects overlapping each other. The lady overlaps the wall of the well, the well overlaps the trees and bushes, the trees overlap the building. This is an easy way to show dimension, so when drawing value sketches, overlap whenever possible.

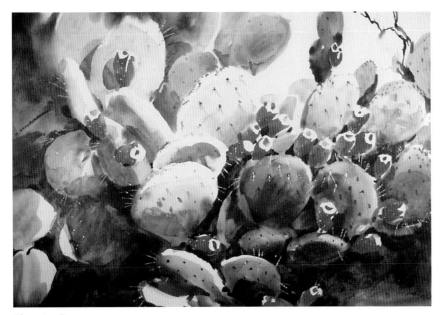

Flowering Cactus
Strathmore Crescent 114 cold-press board
22″×28″ (56cm×71cm)
Collection of Chris Ruys

Different Value or Color

Overlapping planes must be either different values or color. Place your center of interest in one of the inner coordinates. (See page 62.) Now place other elements behind the center of interest. The values of these two planes must be different enough to show that one is in front of the other. Three overlapping planes achieve good dimension if the value pattern has been worked out.

"Flowering Cactus" lends itself well to overlapping. The flowering part is the center of interest, and the green part that overlaps creates dimension. The complementary colors of red and green also create dimension, along with the vibrant colors around the center of interest and the gray color used as the plants recede.

Exercise

Take one of your painting scenes and divide it into different planes, kind of like a child's pop-up book. The center of interest usually falls into the middle plane as shown here.

EXERCISE

Visit a museum and see how your favorite paintings there show depth. Break the paintings down into simple large planes, like the foreground, a middle ground and background. Count the dimensional elements and combinations of these elements the artists used. Studying the art of the great masters is a good way to learn. Incorporate what you see and learn into your own works of art.

Hard and Soft Edges Create Dimension

wet-into-wet

wet-into-wet

wet-into-wet

apply grass wet-
into-wet and dry

dry surface

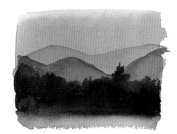

hard edge

wet square and paint through
with loaded brush

spatter into wet and onto dry

dab wet-into-wet and onto dry, then
spatter water into wet area

wipe out with brush

scrape at different
times with end of brush

scrape out with
end of brush

Exercise

Creating different types of edges in watercolor can be tricky. The best way to learn to control edges is to take a lot of scrap paper and practice.

Doodling is really a better word for this exercise. Have patience—it's a requirement for the art of watercolor. Your paper must be bone dry to achieve hard edges. For soft edges the paper should be damp or just plain wet to allow the pigment to bleed creating a soft, blurred effect. Control of the water-to-pigment ratio is what makes the edge either bleed or stay put.

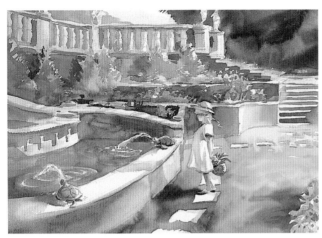

Tara Turtles
Arches 300-lb. (640gsm) rough paper
14″×19″ (36cm×48cm)

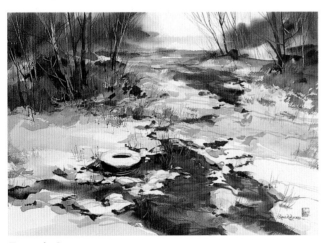

Tire in the Snow
Arches 140-lb. (300gsm) rough paper
15.5″×22″ (39cm×56cm)

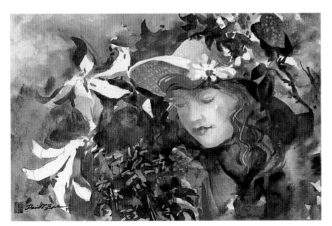

Flower Girl
Strathmore Crescent 112 rough board
14″×18″ (36cm×46cm)
Collection of Kathrene Wales

Focal Point

Always put your hardest edges and the highest contrast of values into your center of interest. This brings the center of interest forward and makes it the focal point that guides the viewer into your painting. A good rule of thumb is hard edges along with high-contrasting values bring areas and objects forward. If you have soft or hard edges along with similar values, the area or objects stay flat unless the two values are of different color.

Blurred Edges

In this painting the center of interest is created by the lightest light and darkest dark together with hard edges around the area of the tire, or what I like to call the *area* of interest. This is another reminder that the center of interest is not always a single object; many times it's a whole area.

Light and Dark

Soft, blurred edges fall back when put next to hard edges even with a little contrast present. It's like the depth of field a camera uses to show areas in and out of focus. The hard-focused area is what your eyes pick up first, then they move around the picture trying to focus on the blurred area. The eyes pick up on the fact that they can't focus on the blurred areas, so they go back to the hard-focused area or center of interest.

Use Perspective for Dimension

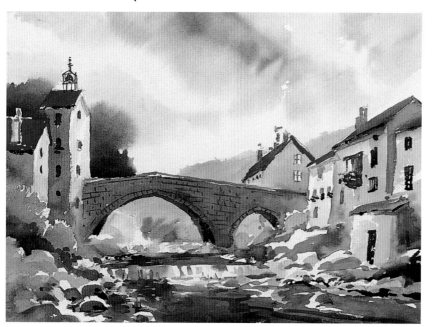

Italian Bridge
Arches 300-lb. (640gsm) rough paper
10″ × 14″ (25cm × 36cm)

Perspective is Always Present

Linear (point) or aerial perspective is present in every painting with dimension, even when there are no structures in the painting. Linear refers to perspective that includes a vanishing point or points on, above or below the horizon line. Aerial perspective uses contrasts of value, hard and soft edges and color to create dimension. Both types of perspective work to create dimension in "Italian Bridge."

> **TIP**
>
> Entire books are written on the subject of perspective, which gives you an idea how important and sometimes complex it can be. It's worthwhile to read more about perspective.

> **TIP**
>
> Here are some helpful definitions pertaining to perspective.
>
> **Vanishing point:** The place at which parallel lines that lead off an object converge or seem to converge at the horizon line or at a far distance away from the object.
>
> **One-point perspective:** All the receding lines of an object go to one vanishing point.
>
> **Two-point perspective:** Objects have two receding planes that go back to vanishing points that fall in opposite directions.
>
> **Three-point perspective:** Similar to two-point, with the addition of another vanishing point either above or below the other two: if two points fall on the horizon line, the third point falls vertically above or below the horizon line.
>
> **Aerial perspective:** Consists of color changes that happen as a scene recedes and changes from sharp foregrounds to blurred backgrounds. The only difference between aerial and linear (point) perspective is the lack of a vanishing point in aerial perspective.

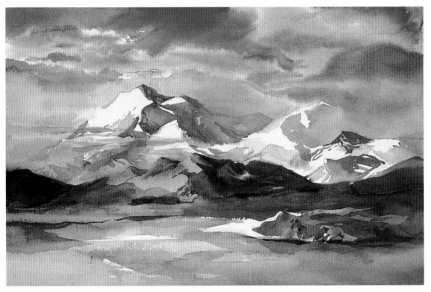

Aerial Perspective

When viewing a landscape with the distance of a few miles, aerial perspective is what gives dimension to the scene. It shows the color changes as the picture recedes. When working aerial perspective into your painting, use more intense colors in the foreground and lessen the intensity as you recede to the background. Foreground edges should be sharper, blurring as you move back. For example, a mountain in the distance has soft edges, values are softly contrasted and the colors are engulfed by the colors of the background sky.

Many times you'll use a couple different elements of perspective to achieve the dimension you're looking for. For instance, you automatically use two-point perspective and aerial perspective in a landscape that shows a sky and the sides of a building. It's automatic—all you need to do is make sure the drawing and value pattern are up to par and the painting will have dimension.

Mountain Clouds
Arches 300-lb. (640gsm) rough paper
14″×22″ (36cm×56cm)

Nick's Barn
Arches 300-lb. (640gsm) rough paper
11″×15″ (28cm×38cm)

TIP

To figure out the perspective and vanishing point on an object that is rounded and doesn't have distinguishing parallel lines, simply imagine the shape to be cubed. Then work out the perspective and turn it back into its rounded shape with correct perspective in place. This can be done either in your imagination or on a piece of scrap paper.

Color

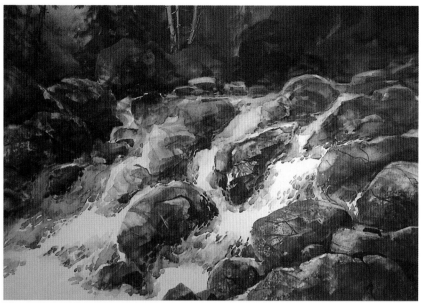

Quebec Runoff
Strathmore Crescent 112 rough board
14″×19″ (36cm×48cm)

Warm Protrudes, Cool Recedes

Warm and intense colors protrude, while cool and muted colors recede. It's that simple. So, work the more intense color into your foreground and area of interest, like the front rocks here. Use less intense color in the middle ground, away from the center of interest, and in the background. Also be sure your edges and contents are soft.

If warm colors in the background and cool colors in the foreground are needed, such as in a winter scene, just use intense cool colors in front and muted warm colors in back.

Complimentary Flowers
Arches 300-lb. (640gsm) rough paper
15″×11″ (38cm×28cm)

Complements Show Dimension

Complementary colors hold a painting together. Use them to show dimension as in this painting. The flowers are red, so a green background makes the flowers stand out even with the same values. It doesn't matter what color an object is as long as there's a good value pattern and the edge control and perspective are in order. If you're getting frustrated choosing color schemes, I suggest you use complementary colors. Give the center of interest the more intense color, then use its complement to paint the other parts of the painting.

TIP

My most popular saying (meaning I reiterate it often) is "anything can be any color." This is true because of lighting and reflective lighting. If a room has a very blue light source, everything in that room will have a blue color cast. If a yellow vase is placed on a red table in a room that has a blue light source, the vase will actually be three colors: the original local color yellow, the reflective color red and the lighting color blue.

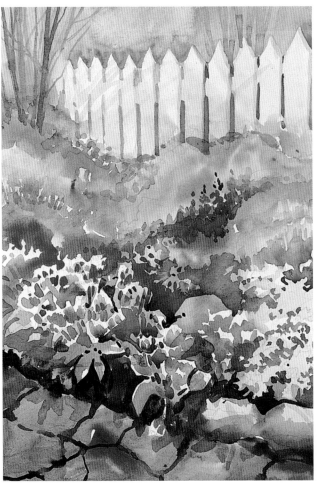

Fence and Flowers
Strathmore Crescent 114 cold-press board
13.5″×9″ (34cm×23cm)

Worry About Color Last

Practice drawing, do value sketches, practice other dimension techniques and, after you have a firm grasp of all these things, then work on the color aspect of your painting. I guarantee if you get everything else figured out, color won't be any problem, and when it comes time to select colors, they'll automatically come to you. Not every painting you do has to be a rainbow of color. If you do use a colorful palette, be sure that each color harmonizes with the same color elsewhere in the painting.

> ## TIP
> Next time you're at a shopping mall, look at display windows and pick up good color schemes from clothing designers. Many stores carry the latest crazes, colors that are in fashion and colors that work together. Not only will your paintings have a good color scheme but they'll be in style. Maybe you'll even create the next color-scheme craze.

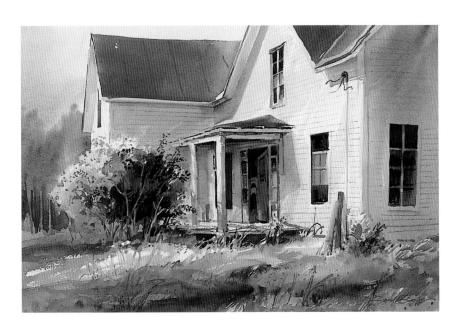

Gilmer Porch and Shack
Arches 300-lb. (640gsm) cold-press paper
14″×19″ (36cm×48cm)

Separate Layers to Show Dimension

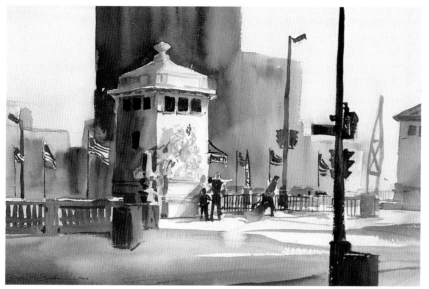

Bridge Keeper
Arches 300-lb. (640gsm) rough paper
14″ × 22″ (36cm × 56cm)

Think and Paint Layers

Think and paint *layers* rather than objects. The layers are like the planes mentioned before: foreground, middle ground and background. Your goal is to create a simple value pattern divided into large layers or planes. The more you arrange a grouping of objects by putting them within a layer, the easier it is to compose and paint. Break your paintings down to simple planes, then separate those planes with the dimensional principles we've talked about: overlapping, hard and soft edges, perspective and color.

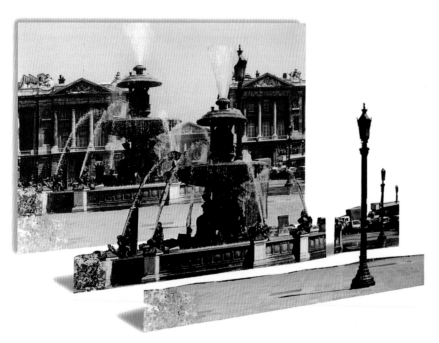

Exercise

For a fun way to learn about layers in a painting, take a photograph that's well composed and get three duplicates made. Cut out the foreground objects as one plane from one photo, the middle ground from another. Then place the middle ground cutout on top of the background of the third photo. To add a little dimension, place something with a little thickness between the two pieces of photo. Now place the foreground cutout on top of the middle ground cutout. This gives you a storybook, animated kind of feeling. It also teaches you how you should be thinking in layers when planning your painting. An added benefit—it makes a great greeting card that someone would love to receive!

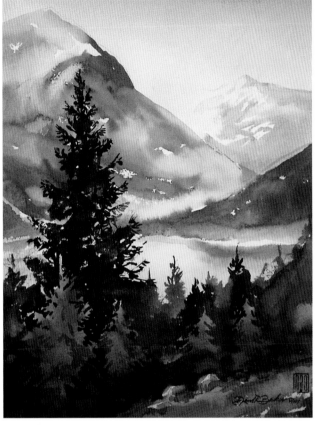

Contrast and Value Separate Layers

The first step when separating layers in a painting is to take a group of objects, such as a crowd of people or a grouping of trees, and turn it into a simplified pattern. Accomplishing this can be as simple as keeping the values closely related within the group. Then place the patterned grouping into a layer. This painting has basically two big planes, a foreground which is the dark trees, and the background which is the light mountain.

Pine Lake
Arches 300-lb. (640gsm) rough paper
10″ × 14″ (25cm × 36cm)
Collection of Lenore Murphy

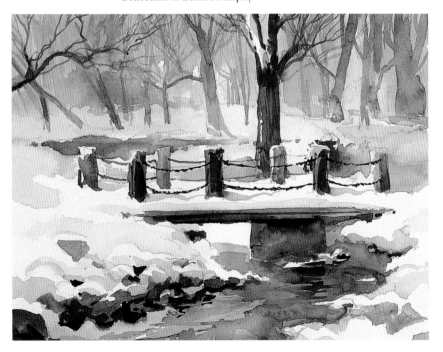

Pattern layers around each other so they look separated enough to show dimension. If, for example, a layer contains a simplified grouping of trees that are a light value, the layer behind those trees needs to be a lighter or darker value. This brings the trees forward and separates the layers at the same time.

Near Kathleen's Folks
Arches 300-lb. (640gsm) rough paper
11″ × 14″ (28cm × 36cm)

Layer With Negative Painting

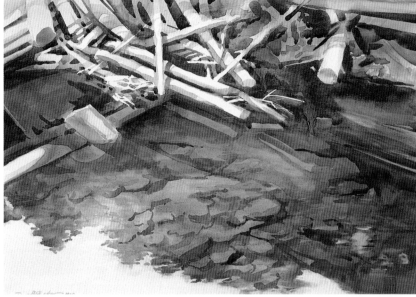

Rock Reflections
Strathmore Crescent 114 cold-press board
13″×18″ (33cm×46cm)

Darks Around Light

Negative painting is an effective way to create layers in a watercolor. It occurs when you create the shape of an object or just a shape by painting a darker value around a lighter value. For example, I painted around the tree branches in this painting with a darker value to form the actual branch. The branches could be any color or value as long as the value used to paint around them is darker.

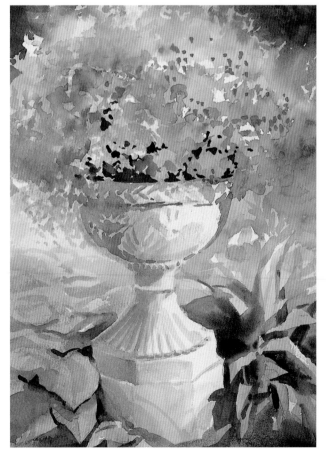

Monti Fiori Foliage
Arches 300-lb. (640gsm)
rough paper
14″×10″ (36cm×25cm)

Use the White Paper

On white watercolor paper outline an object or area and paint around it. It's like doing a silhouette in reverse. Painting around the white creates the shape of the object.

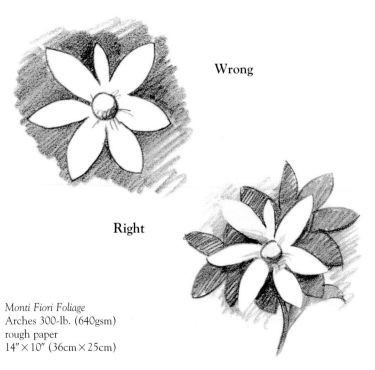

Wrong

Right

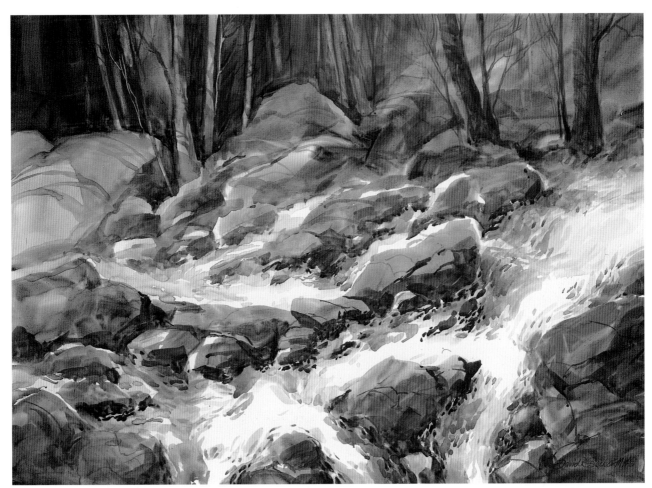

Watercolor Runoff
Strathmore 5-ply bristol board
20″ × 26″ (51cm × 66cm)

Use Positive and Negative

To use the negative painting technique, first, paint in the light color which becomes the shape of the object. Then paint the dark object around the light object. Think of the dark as an object and not just a dark mass. This kills two birds with one stone—you create the shape of an object with the dark color while defining the light object. The detail shot of this painting shows you how to use this technique.

Most watercolorists use about three layers when working with negative painting. First, the light layer is painted, which becomes the shape of the front objects after the second and third layers are applied. Next, a middle tone is used to cut out the shape of the object from the first layer. Then the darkest layer is applied, which cuts out the shape of objects in the second layer and also the objects in the first layer.

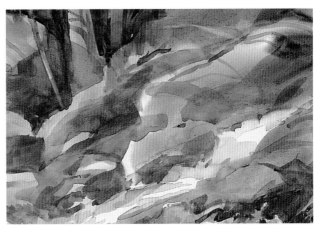

TIP

Negative painting is one of those techniques you definitely should work out on a piece of scrap paper or in a sketchbook before you jump to your painting.

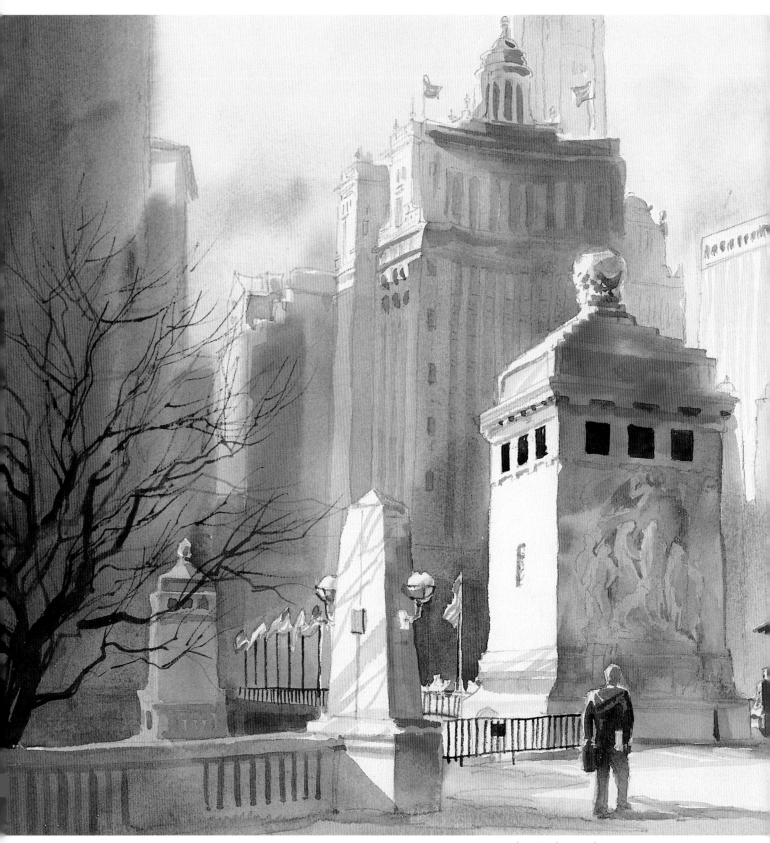

Looking South on Michigan
Arches 300-lb. (640gsm) rough paper
14″×17″ (36cm×43cm)

6 Color

Color in a painting is like color on a classic car. It looks great, but if you changed the exterior color of the car, the engine would still be the same. Think of the value pattern as the engine of a painting's composition and color as the embellishment. Once you've learned the basic elements of composition discussed previously, the use of color will naturally and automatically come to you. At that point you can embellish your painting with color.

Value Then Color

Value Pattern

Work out the value pattern of your paintings first, then add the colors to match the values of your value pattern. If your composition doesn't have a good value pattern, all the wonderful colors in the world won't help your painting.

A value pattern comes first, before color, but when you use color, make sure the more vibrant, intense colors are in the center of interest, where you want the viewer's eyes to go first.

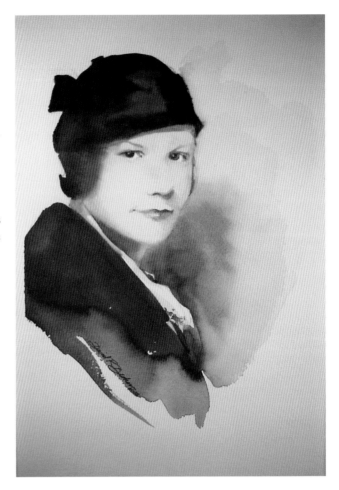

Kris's Grandmother
Arches 260-lb. (356gsm) cold-press paper
9″×14″ (23cm×36cm)
Collection of Kris Scoma

> ### TIP
> Always add fresh paint to your palette. If you use only dried paint, your colors will look washed out.

Coffee Pot Still Life
Arches 300-lb. (640gsm) rough paper
10″×13″ (25cm×33cm)

Dennis
Arches 300-lb. (640gsm) rough paper
10″×14″ (25cm×36cm)

Squint

Take a good look at this colorful painting—now take another look, but this time squint at it. Squinting diminishes the color and shows you what the value of that color is. The value pattern stands out no matter how colorful the painting. Instead of seeing the color, you see only the large value masses when you squint. Keep in mind the intensity of the color as you figure out its value. Don't place an intense color even with the correct value in an area that you want to recede.

TIP

To see an image in one color, look at it through a piece of colored cellophane. The entire picture will be in values of the colored cellophane.

TIP

Color value sketches help you determine what dimensions and colors to use in a composition, but many times completing a value sketch, a sideline sketch and then a color sketch is just too much to do. I suggest you work on only the value sketch and a sideline sketch. After awhile you may feel that you want to explore the area of color more in your painting. Then would be a good time to start doing color value sketches.

Color Wheel

1 = primary

2 = secondary

3 = tertiary

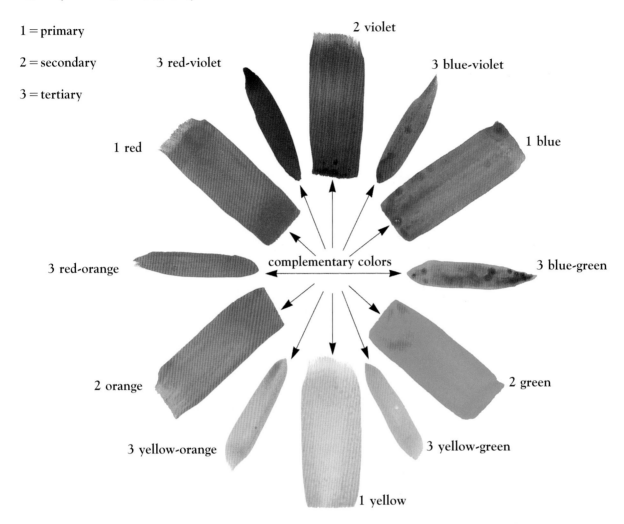

2 violet

3 red-violet

3 blue-violet

1 red

1 blue

3 red-orange

complementary colors

3 blue-green

2 orange

2 green

3 yellow-orange

3 yellow-green

1 yellow

Primary and secondary colors: The most important aspects of the color wheel are the primary colors—red, yellow and blue—and the secondary colors, which result from mixing two primary colors. Violet is the mixture of blue and red; green results from blue and yellow; and orange is the product of yellow and red.

Tertiary colors: Tertiary colors result from mixing a primary color and a secondary color. For example, when blue, a primary color, is mixed with green, a secondary color, the result is blue-green, a tertiary color.

Complementary colors: Complementary colors fall directly opposite each other on the color wheel. Complements can free you from color dilemmas; for example, if a painting is predominantly blue, use its complement, orange, for dynamic results. Mixing two complementary colors produces grays and browns. For instance, if you need to gray down a green, add a little red. This works for every complement.

Make your own color wheel: The best way to become familiar with your colors is to experiment mixing them. A good place to start is by making your own color wheel. Use the color wheel here as a guide.

Begin with the three primary colors: blue, yellow and red. In the color wheel on this page, I painted blue at two o'clock, yellow at six o'clock and red at ten o'clock.

Now mix two primaries in the same portion to make the secondary colors, and place them on your color wheel as shown here.

Fill in the blank spaces with tertiary colors. Mix a primary and a secondary to make each of these colors. For example, mix yellow with green and place the resulting tertiary color in between yellow and green.

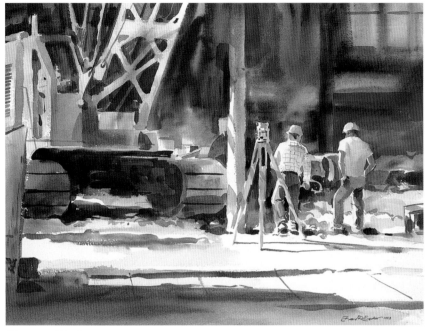

Chicago and Rush
Arches 300-lb. (640gsm) rough paper
22″ × 28″ (56cm × 71cm)

If in Doubt Use Complements

When picking out a color scheme for your painting, I suggest the use of complementary colors as a dynamic, almost foolproof choice. (In this painting I decided the main color scheme should be orange and blue.) This doesn't mean you can't include other colors in your painting, but using a higher percentage of complementary colors can free you from problems with color choice.

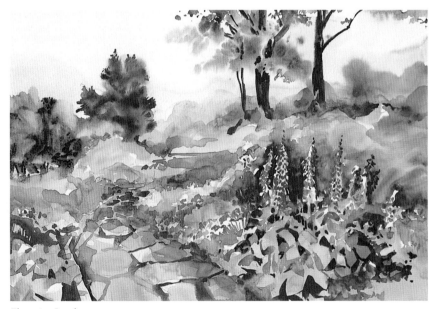

Flowering Landscape
Strathmore 5-ply bristol board
14″ × 19″ (36cm × 48cm)

Harmonize

Harmonize colors throughout your painting. If a color stands out too much and is distracting, add it to other areas of the painting to create a better balance throughout the picture.

TIP

If you have trouble remembering the color wheel—which colors complement each other or which colors are next to each other—set up the arrangement of colors on your watercolor palette to correspond to a color wheel. This way you can refer to your palette while in the middle of a painting.

Local Color and Light

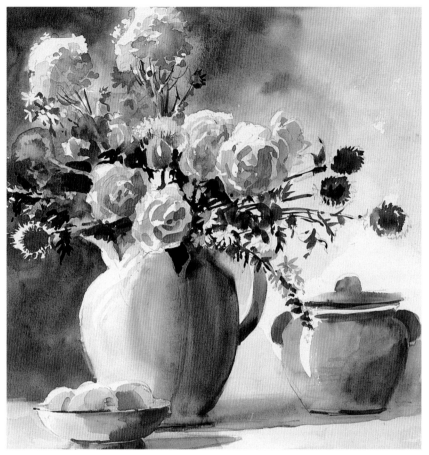

Strong Light Still Life
Strathmore Crescent 112 rough board
13.5″ × 13.5″ (34cm × 34cm)

Light Affects Color

Local color is the actual, "true" color of an object seen under normal daylight. If you paint a wagon red, that's the local color of the wagon. If the sun shines on the wagon making it look orange or pink, the local color is still red. The type and intensity of light is important to the composition of your painting, however.

If you use intense sunlight or manmade light as your source, the light pattern will most likely consist of light areas where the light source hits directly and dark areas where shadows are cast.

I recommend using intense lighting when you begin painting, so the value pattern is well defined and eye flow can be easily directed with the patterns of light and shadow.

In this painting the local color is hard to determine because of the backlit lighting. The objects are silhouetted so what you see is the shadowed color. This is just another way light affects color.

Danger Ahead
Strathmore 5-ply bristol board
23″ × 29″ (58cm × 74cm)
Collection of Mary Pat Hutton

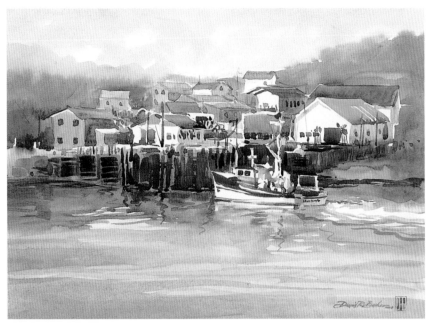

Getting Home
Strathmore Crescent 114 cold-press board
14″×19″ (36cm×48cm)
Collection of Dayle Sazonoff

Overcast Light

When painting in overcast light use the values of the local color to determine your value pattern. The shadows in overcast light aren't defined, so you can't use them to direct eye flow. If the local color isn't the right value for your pattern, you'll need to change the color to a hue with the correct value and intensity. This can be frustrating and is the reason why I recommend you use intense light when learning watercolor.

Make local color play an important role in the dimension of an overcast scene. Objects in the foreground will have more intense local color than those in the background.

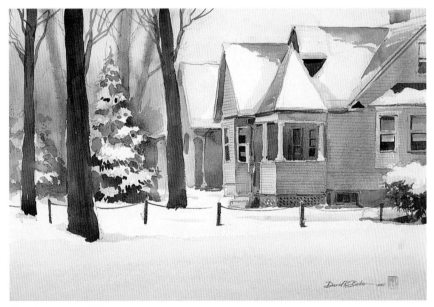

Kenosha House in Winter
Arches 300-lb. (640gsm) rough paper
14″×21″ (36cm×53cm)

Grass Isn't Always Green

Here's my favorite saying again: "Anything can be any color." By definition, an object can be any color depending on the color of the light source and accounting for reflective light. So a field of grass, where the local color is green, can change to an orange-green if the light source is that of an orange sunset.

Don't assume an object is a certain color because of its name, like an orange isn't always orange and blonde hair isn't always blonde. Consider the local color of the subject, the objects around it, the light source and reflected light.

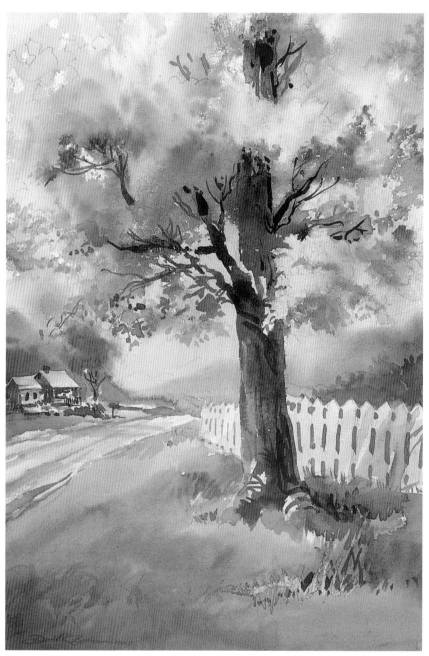

Autumn Road
Arches 300-lb. (640gsm) rough paper
14″×21″ (36cm×53cm)

TIP

Paint on a scrap sheet of watercolor paper when experimenting with colors that you don't normally use. This lets you try the colors and learn how the paint handles without being afraid you'll ruin a sheet of expensive watercolor paper.

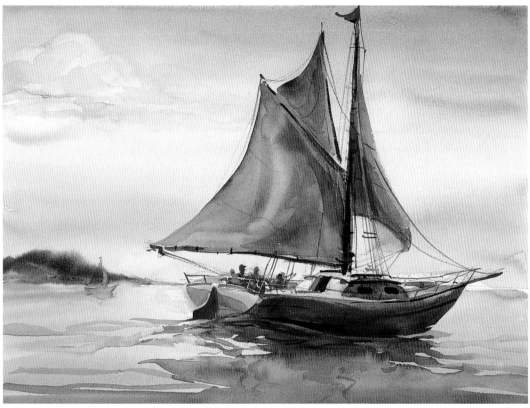

Sunset Sailing
Arches 300-lb. (640gsm) rough paper
14″ × 19″ (36cm × 48cm)

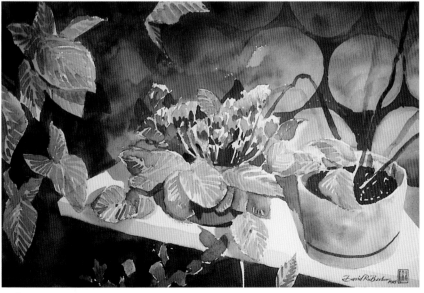

Violets
Arches 300-lb. (640gsm) rough paper
15″ × 21″ (38cm × 53cm)
Collection of Clare Tate

Suit the Color Scheme

Don't copy the exact colors you see in photographs. This brings nothing to the party. You need to overemphasize colors you see and add or remove colors if necessary. When starting a painting, decide on a palette of color that best suits the color scheme of the subject.

Color and Aerial Perspective

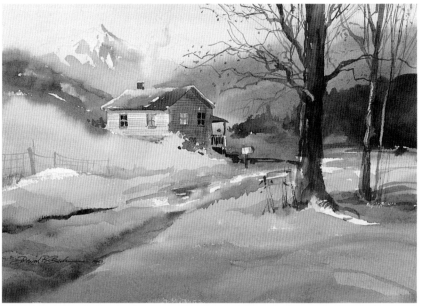

Warmth in the Studio
Arches 300-lb. (640gsm) rough paper
10″ × 14.5″ (25cm × 37cm)

Combine Color and Edge Control

No matter what your subject, aerial perspective should be in the formula for creating your painting. Use color and edge control to achieve aerial perspective. Foreground areas will have intense colors and hard edges. As you recede into the painting the colors become less intense, more muted and grayed. Edges become soft and the areas blur. An easy way to show aerial perspective is to put the color of the sky into the background objects as in "Warmth in the Studio" and "European Glow."

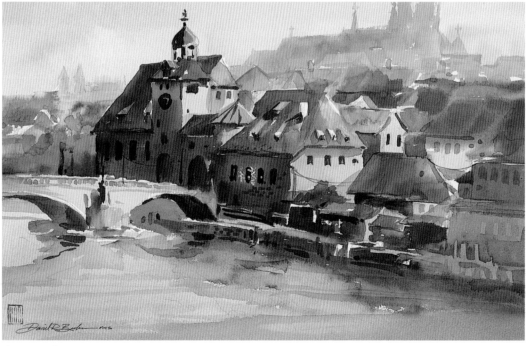

European Glow
Arches 140-lb. (300gsm) rough paper
11.5″ × 18″ (29cm × 46cm)

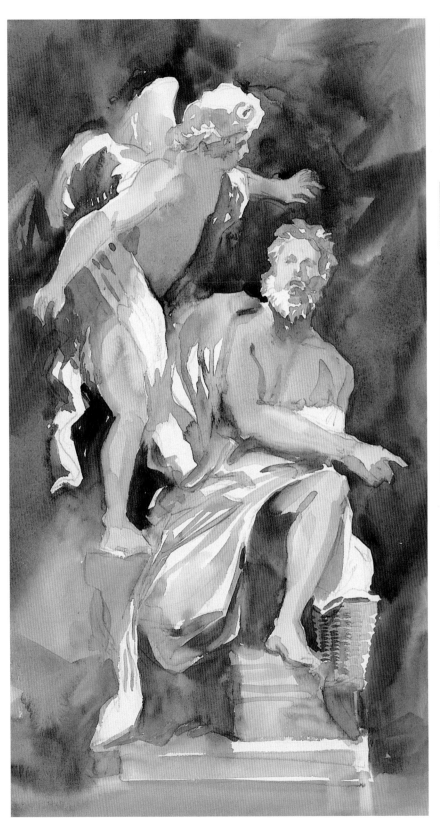

Aerial perspective is important even if the depth is only a foot. The human eye doesn't see much of a blur or soft focus at that distance, but you can get good dimension in this type of painting if you lessen the intensity and blur the background objects even if the distance is short.

TIP

Look through a camera and check out how easy it is for the lens to show depth of field—focusing on the center of interest but blurring other areas. Our eyes actually do the same thing. Stop and stare at a particular object and you'll notice the depth of field just as seen with a camera. The object you are staring at will be in focus while the areas around and behind it will be blurred and out of focus.

Sculpted Cupid
Strathmore Crescent 114 rough board
10″ × 19″ (25cm × 48cm)

Artistic License

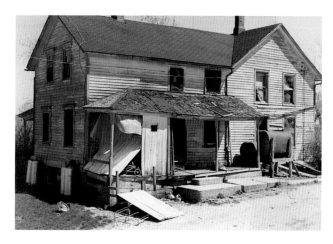

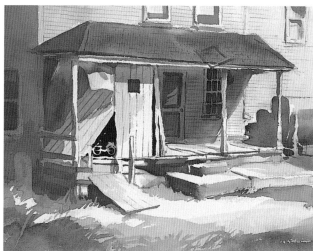

Do What You Have To

Artistic license lets you do anything when it comes to making your painting look and work better. It comes in handy when working with color. For example, if the colors in your photograph seem all wrong for what you want to show in your painting, go ahead and change them to best represent what you're trying to convey.

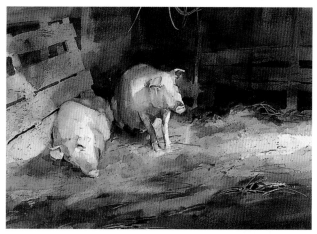

Awakening Pigs I
Arches 300-lb. (640gsm) rough paper
12" × 17" (30cm × 43cm)

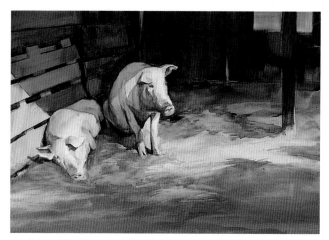

Awakening Pigs II
Strathmore 5-ply bristol board
12" × 16" (30cm × 41cm)

Use artistic license to change images to best interpret what you saw on the spot and what's in your photograph. Enhance and change them as I did with "Awakening Pigs I & II." Both paintings were done using the same photo. "Pigs I" was done using the photo and a sketch I did on the spot in the barn. "Pigs II" was done only from a photo. I added a beam because I felt something was needed to stop the view, or flow, from running off the right side of the page.

Do paintings of sculpture, but instead of painting them to look like stone or plaster, use your artistic license and turn them into lifelike objects with fleshtone colors.

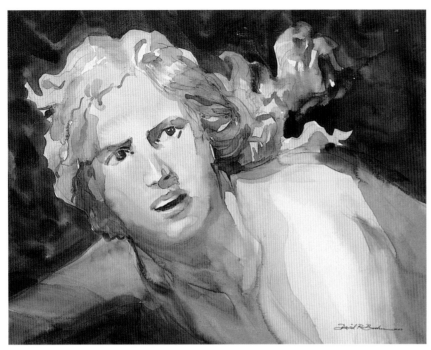

Rock Life
Strathmore Crescent 114 cold-press board
10″×13″ (25cm×33cm)

Go ahead and add objects to your composition to make the painting look better, but as a rule don't just include them as an afterthought. Sometimes, however, if a painting just doesn't turn out, adding to it can work. In this painting I added the leaves on the upper left as an afterthought. It's not something I recommend, but sometimes it has to be done.

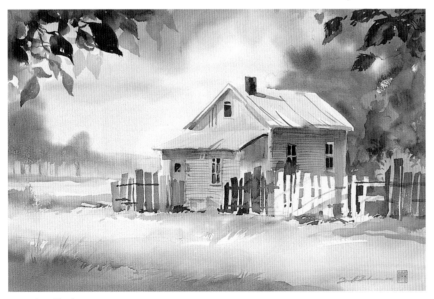

Fenced-in Shack
Arches 300-lb. (640gsm) rough paper
14″×21″ (36cm×53cm)

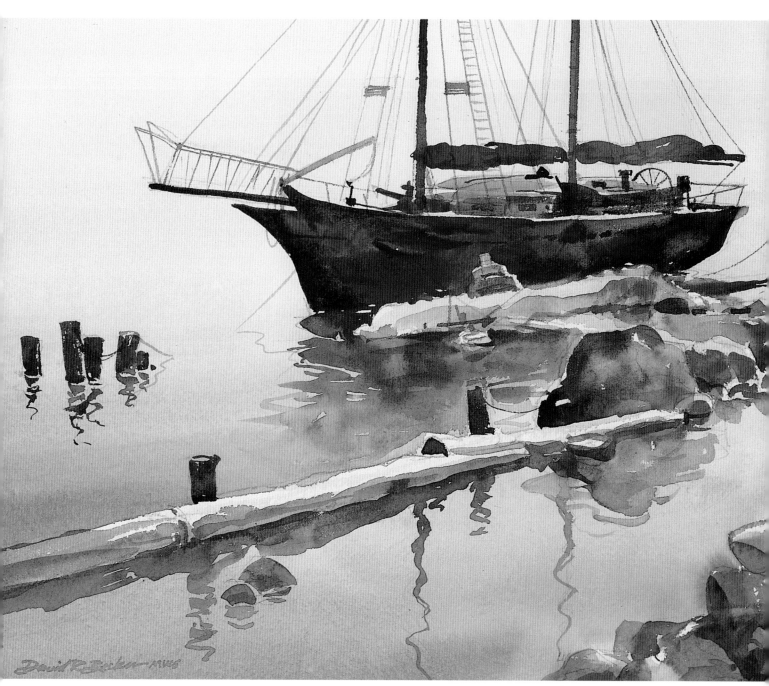

Sitting In Kenosha
Arches 300-lb. (640gsm) rough paper
12″×19″ (30cm×48cm)

7 Put It All Together

In this chapter we'll practice many of the basic elements
talked about throughout the book by completing
step-by-step demonstrations.

DEMONSTRATION: *Put People Into Your Composition*

The Photo
This photo needs more life; it looks a lot like a stage backdrop. People are needed to finish off the composition.

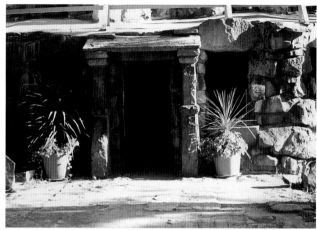

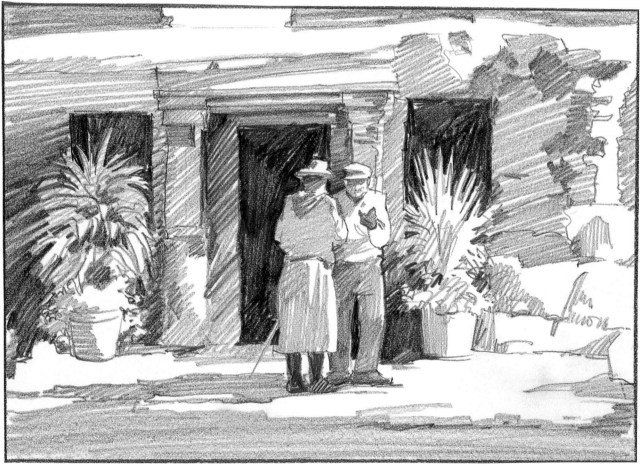

1 Value Sketch
Roughly sketch in some figures, keeping in mind that they'll be the center of interest. Without the figures, this reference is just a good-looking building. Figures add life and a story to the painting.

2 Sideline Sketch

After I do my rough-in of the figures in a value sketch, I do a more finished study of the figures, which I call a sideline sketch. Do the sideline sketch on a scrap piece of paper and figure out the proportions, the lighting and the positions of the figures. If you can't make up the figures in your head or don't have a photo reference, try to get someone to pose for you. It's important to think out all the problems you could run into with the figures. Plan, through your value and sideline sketches, before you apply pencil or paint to the watercolor paper.

TIP

Always think of your paintings as exercises and not as finished works of art to sell or enter in a show. If you think of them as exercises, I guarantee your knowledge will increase and your skill will improve.

3 Save Whites and the First Wash

Determine right from the start to use the white of the paper as your lightest lights. Use an HB pencil to rough in the drawing on your watercolor surface. Don't use too hard a lead because it will scratch the paper and leave a groove. Use some liquid frisket if you need to save a light spot that you can't paint around. Then paint the large masses of the areas that are only *slightly* darker than the white of the paper, leaving the lightest areas white. Wash over areas that will receive a second wash, like the plants and some of the shadows. Keep your washes fresh and clean so you don't have to go over the same area again and again. The fresher and cleaner the wash, the more professional the painting will look. Paint into the figures as much as possible when working the large washes, but be careful not to paint into areas that will remain light.

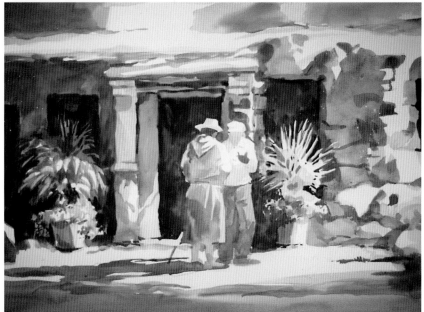

4 Second Wash

It's very important to wait for the first wash to dry before starting to paint over it. Paint the second wash with middle tones and darks. Use these values to carve out objects and areas that will in turn bring dimension to the painting. This process is called negative painting. Negative painting creates objects that visually protrude forward by using a darker value around the light objects, like the plants in this painting.

Don't treat the figures any differently than any other part of the painting—such as painting them last. If you do, the edges will be too hard and it will be difficult to achieve the same look and feel as in the rest of the painting.

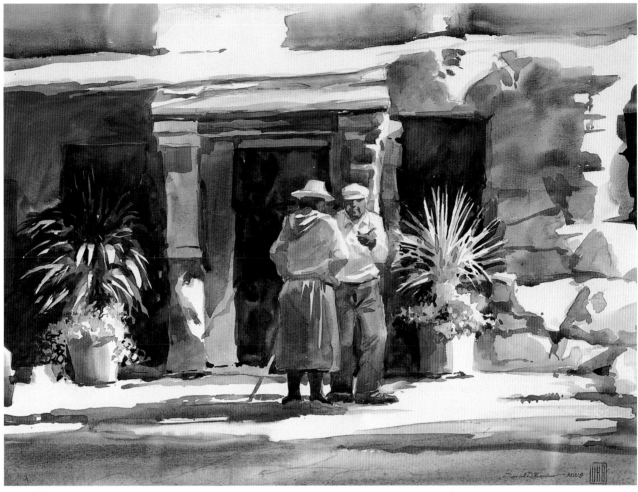

5 Details

Pull out your small brushes and put in the finishing touches on your painting. Stop when you start searching and wondering what else you can do to the painting. When this happens, put down your brushes. You're finished.

Helping Hand
Strathmore Crescent 112 rough board
14″ × 19″ (36cm × 48cm)

TIP

Before using a new brand of paint, new colors or painting materials like liquid frisket for the first time, test them out on a piece of scrap paper.

DEMONSTRATION: Composing Groups

The Photo and Black-and-White Photocopy

The groups of objects in this photo are too complex to paint the way they are positioned. We'll take this complex group of objects, simplify them and make sure the values are the same or closely related.

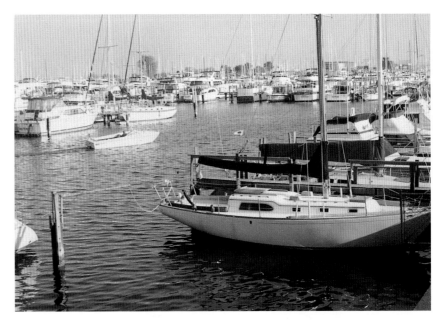

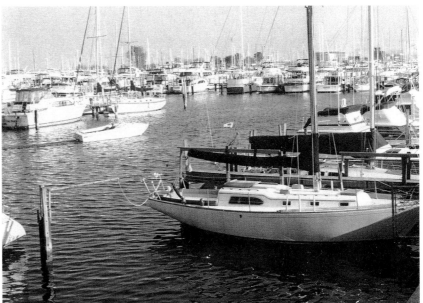

TIP

When painting or drawing any kind of grouping or crowd, look for its outside contour and use that shape as one value mass. If you need more than one grouping, just cut the large one into two smaller groups.

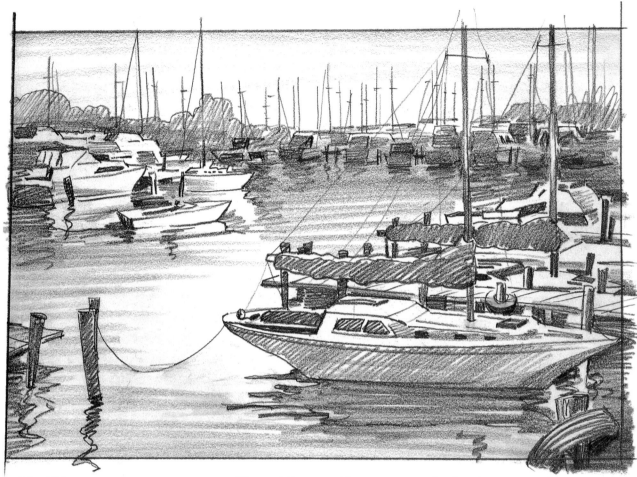

1 The Value Sketch

Simplify detail in your value sketch by grouping objects together into simple value masses. I decided to group the foreground boats together and make them my center of inter- est. The middle-ground boats are combined to make another value mass, and the background boats yet another simplified mass. There you have it—foreground, middle ground and background—a formula that cre- ates good depth. Also lose some of the detail as you recede to create even more depth. When you're in a dilemma about what value a mass should be, I suggest putting dark masses around objects that are light and light masses around objects that are dark. It's simple, but it works.

2 Draw and Wash

Start with a detailed drawing of your subject. The more detailed and accurate at this stage, the better. Be careful not to put any tone on your paper with the pencil; save that for the watercolor. Next paint all the large masses, starting with the background and work forward. Always paint as large an area as possible, and be careful not to lose your hard edges or light areas when putting in the large washes.

3 Second Wash

If you lose some of your line drawing after your first wash, wait for the painting to dry, then re-sketch the pencil lines that disappeared so you will have an idea where to put the second wash. Now, put in all the middle tones and darks wherever possible. Use the middle tones to create the look and shape of the objects in your painting.

TIP

Use liquid frisket only when you need to put down a large wash that overlaps smaller objects you can't paint around. Edges created with liquid frisket tend to be too hard to use for every hard edge in your painting.

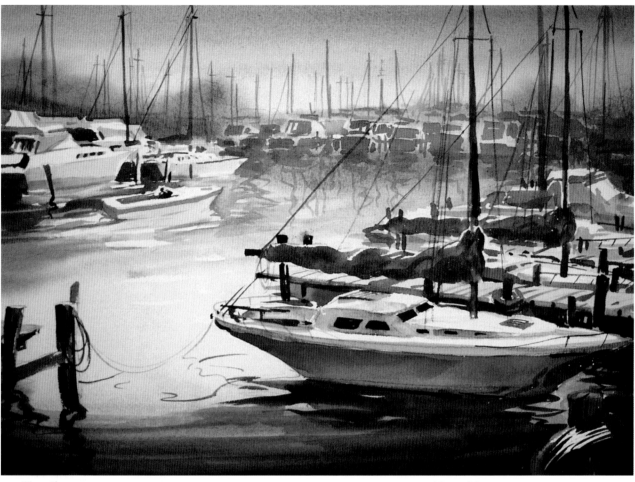

4 Details

Detail is so much fun to paint. That's probably why many beginning artists start their paintings with detail rather than adding it at the end. Don't be seduced. Work the large areas first, then work your way down to the nitty-gritty.

Next to Meigs
Arches 300-lb. (640gsm) rough paper
11″×17″ (28cm×43cm)

TIP

Every so often, buy a set of colors you normally don't use in your palette. Now use only those colors to do a painting. This is a good exercise when you find yourself in a rut, always using the same colors.

DEMONSTRATION: Add Figures and Simplify a Scene

The Photos
These photos consist of a lot of subject matter in an overcast light. There's just far too much content to include in the painting. Try picking out the best parts of each photo and combine them to create one good scene.

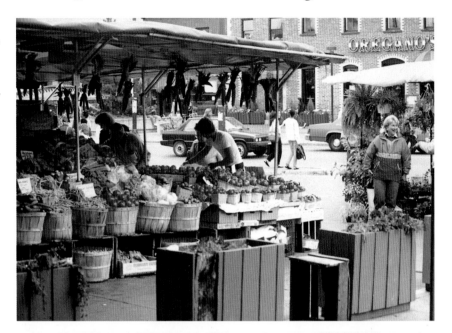

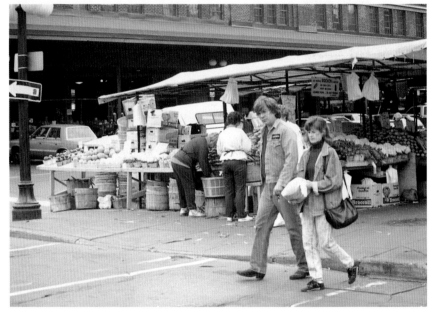

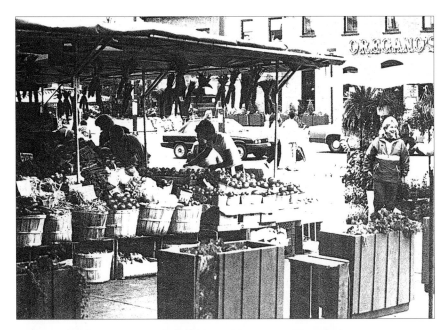

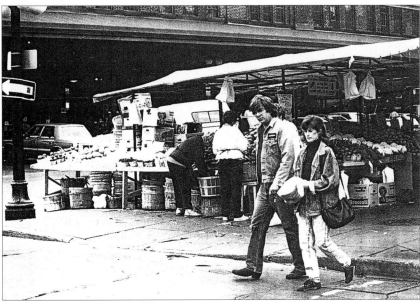

The Black-and-White Photocopies
Make black-and-white copies of the color photographs. This will show you if your photo has a good value pattern or if you'll need to change things around.

Take a good look at these photos and copies and think about what you would do to enhance the composition. Then turn the page to see what I decided to do.

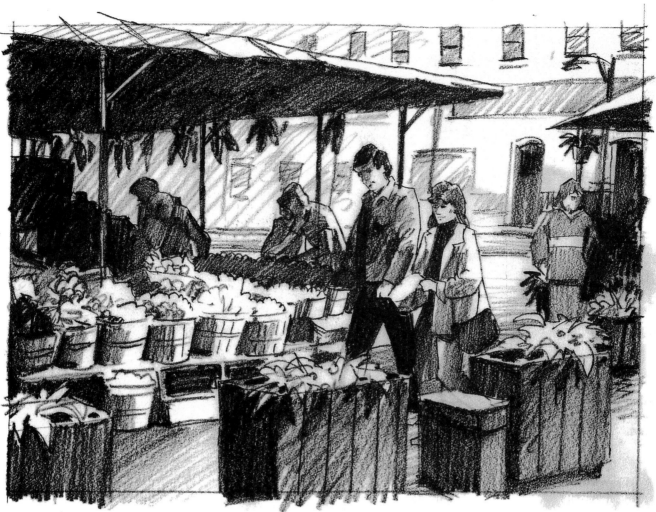

1 Value Sketch

The photos are in overcast light, but I felt the composition needed more dramatic light. I also felt combining people from the photos would liven up the scene. Work on your value sketch until all the changes are corrected and you have a good composition. This gives you a good blueprint to work from. There's no way around it; you must do the sketch because the scene comes from a couple of sources. Notice how I simplified the plants, vegetables and fruits by combining the lights into simple value masses.

2 Sideline Sketch

When you add people and sunlight to a scene, I recommend you do a sideline sketch. Work out all the drawing and shadowing problems before you get to the actual painting. You can't start searching for answers when you're in the actual process of painting.

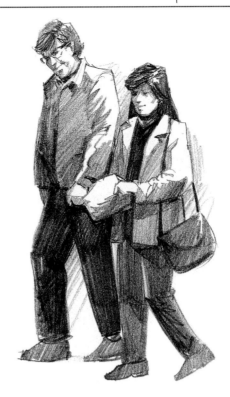

3 Pencil In and Add Liquid Frisket

Pencil in your drawing. Then apply liquid frisket where needed. Paint in the liquid frisket as accurately as possible following the edges of your drawing. The places where the frisket is applied will be very hard-edged, and if the application is not accurate and clean, the edges will stick out like a sore thumb. I didn't use liquid frisket here because I'm confident I can paint around the lights.

TIP

Viewing a value sketch, sideline sketch or painting in a mirror will clearly reveal compositional problems. When a composition or drawing is correct, it'll look good both straight on and in reverse.

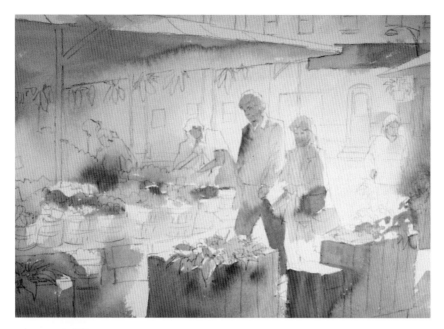

4 First Wash

Cover as much area as possible in your first wash. Pick a simple color scheme of complementary colors and then paint from light to dark with those colors. I've chosen blue and orange for this painting. I put a light wash of those colors on the entire painting, knowing I can go over them with my next wash. Be careful when washing in the light colors that you don't get too dark and lose your lights. With watercolor you can always go darker, but you can't go lighter unless you scrub out, which is something I don't recommend.

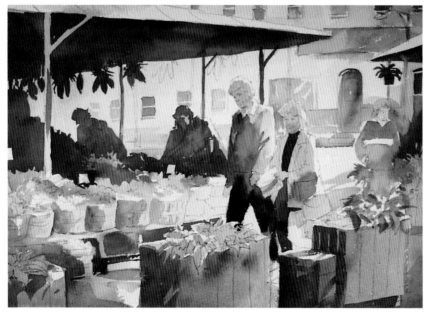

5 Second Wash

Many times it's the second wash that makes or breaks a painting. All aspects of dimension are created in the second wash—soft and hard edges, overlapping objects, color to match the values and negative painting while washing darks on light.

TIP

Many people are impressed when a painter on television finishes an entire painting in a half hour. These artists do many of the same compositions over and over, and they work out any problems way before they ever put paint to paper. Again, it takes longer to plan the painting than to actually paint it.

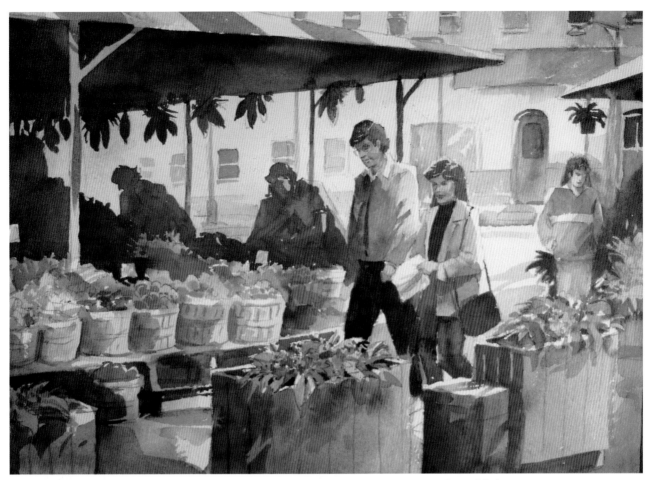

6 Final Touches

When you get to this stage your painting should look almost finished. Putting in the detail is the most fun. When you start questioning yourself about what else needs to be detailed, make sure you stop.

Ottawa Market
Arches 300-lb. (640gsm) rough paper
12″×17″ (30cm×43cm)

TIP

Take a life drawing class if you fear drawing the figure. You can probably fudge a few figures that don't play a big part in a composition, but figures play an important role if you choose to use them in your paintings, and it's worthwhile to learn to draw them well.

DEMONSTRATION: *Enliven Your Composition*

The Photo
Here's a great photo, but the center of interest is dull and lifeless. Many photographs fall into this category. People added to the scene will make a good composition. It's like putting actors on a stage in front of a backdrop.

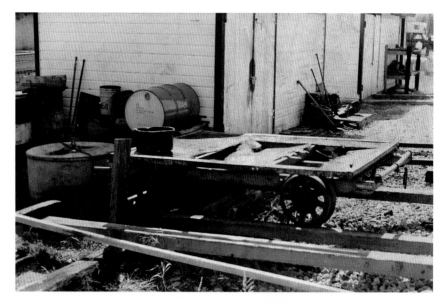

1 Value Sketch

I changed the background to a dark, opposite of what is shown in the photo. The light figure, which will be the center of interest, will then protrude forward due to negative painting.

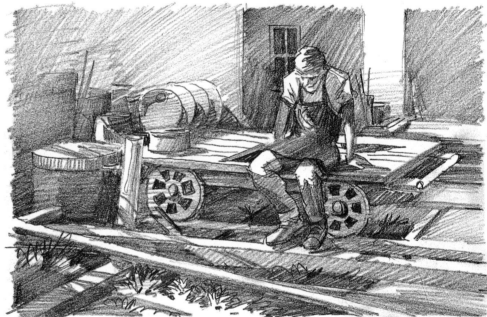

2 Sideline Sketch

Learn to draw from your imagination. Do some very loose line drawings and then pick one of the pencil drawings and shade it in. Learn to draw from your imagination by constantly drawing in a sketchbook without reference. Practice by looking at an image for a couple of minutes, studying the objects and the composition, then look away from the image and try to draw it from memory. If drawing from your imagination is too difficult, get someone to pose for you.

TIP

Combine a photo reference with an image from your imagination. A good life drawing class and practice come in handy when learning to add imaginary images to your photos. In "Thin Ice Dad" I used a photographic reference for the landscape and then made up the two figures.

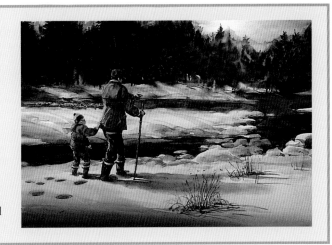

Thin Ice Dad
Strathmore 5-ply bristol board
22″ × 28″ (56cm × 71cm)

3 First Wash

This may sound crazy, but try to paint loose, yet controlled. You should work with large, wet-into-wet washes, but take care in controlling edges and the shapes of the edges. Paint clean!

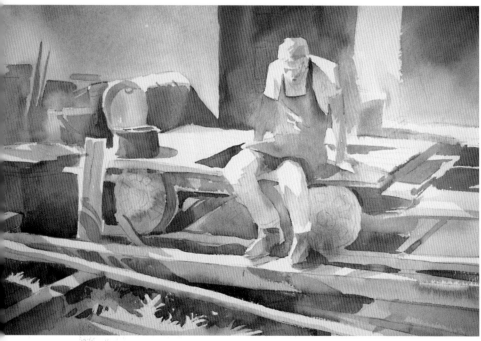

4 Second Wash

Carve out as many masses and objects as possible with negative painting. For instance, the large dark mass behind the figure identifies the objects in the back and the shape of the head and shoulders of the subject in the front. After every wash, stand back from the painting and evaluate what you've done and what you still need to accomplish.

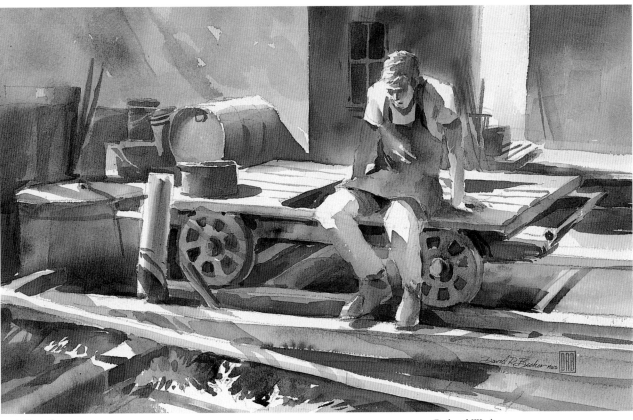

5 Finish

Take your time with the detail. Try to paint as cleanly as possible. A painting can have a few problems yet still look professional as long as you keep the painting techniques looking clean and polished.

Railroad Worker
Arches 300-lb. (640gsm) rough paper
12″×19″ (30cm×48cm)

TIP

Take care to use the right brush for the right job. If you're painting small details, make sure you have a fine, small brush. Change brushes to fit the need.

index